TEXT & PHOTOS B...

Wayne Lynch

Galapagos

A Traveler's Introduction

FIREFLY BOOKS

A FIREFLY BOOK

Published by Firefly Books Ltd. 2018

First printing

Library of Congress Control Number: 2017954253

Library and Archives Canada Cataloguing in Publication
Lynch, Wayne, author
 Galapagos : a traveler's introduction / by Wayne Lynch.
Includes bibliographical references and index.
ISBN 978-0-228-10019-5 (softcover)
 1. Galapagos Islands. 2. Ecology--Galapagos Islands.
3. Natural history--Galapagos Islands. I. Title.
QH198.G3L96 2018 508.866'5 C2017-906128-3

Published in the United States by
Firefly Books (U.S.) Inc.
P.O. Box 1338, Ellicott Station
Buffalo, New York 14205

Published in Canada by
Firefly Books Ltd.
50 Staples Avenue, Unit 1
Richmond Hill, Ontario L4B 0A7

Cover and interior design: Kimberley Young

Printed in China

Canada We acknowledge the financial support of the Government of Canada.

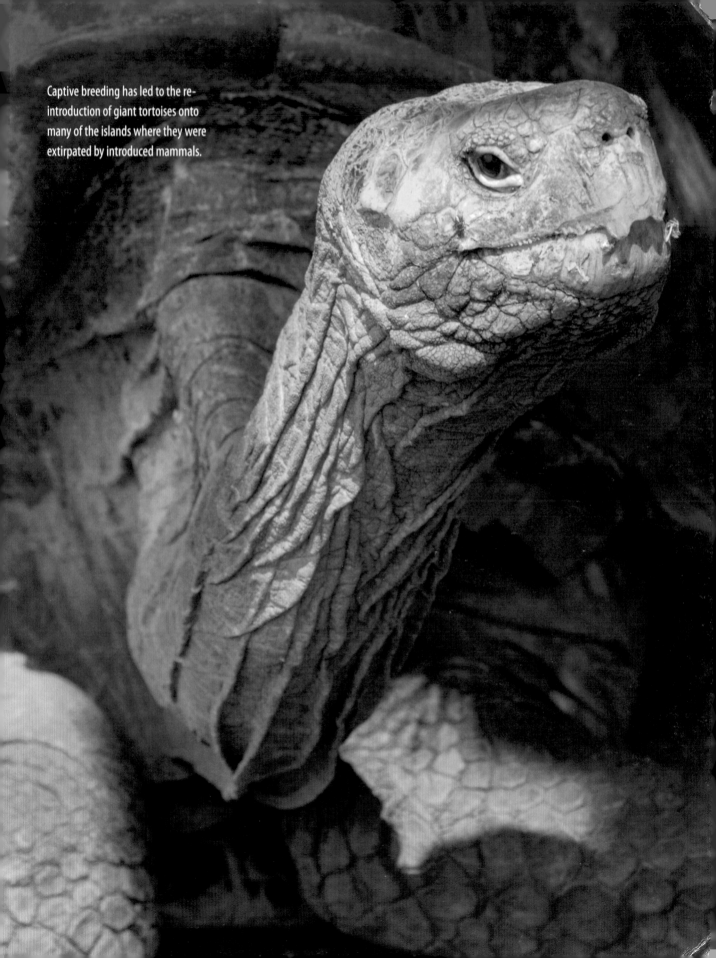

Captive breeding has led to the re-introduction of giant tortoises onto many of the islands where they were extirpated by introduced mammals.

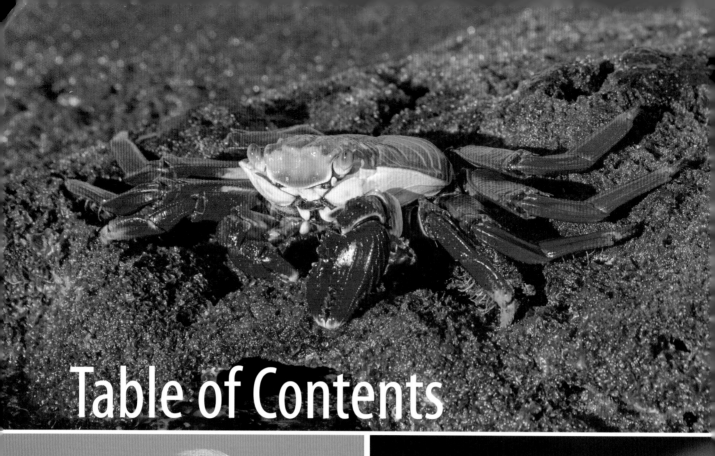

Table of Contents

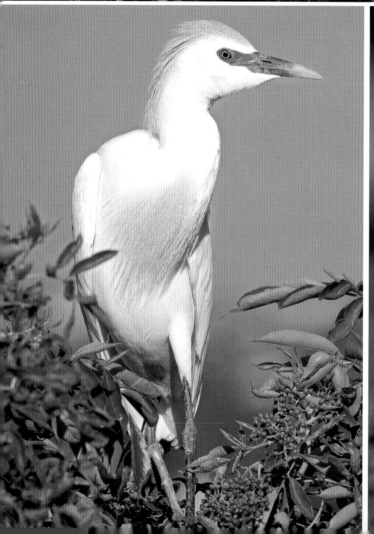

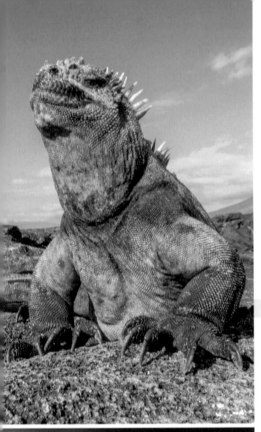

Acknowledgments

Michael Jackson is responsible for my initial fascination with the Galapagos Islands. No, not Michael Jackson the legendary "King of Pop," but the University of Calgary

graduate student with the same name who in 1984 wrote *Galapagos: A Natural History*. His book is still one of the most thorough and thought-provoking science books ever written about this enchanted archipelago. Before it was published, Michael gave a series of lectures at the university to a tour group he was leading to the islands. As part of the course, he asked me to give a talk on photographic techniques, to help his participants take better travel photos. In exchange I could attend his lectures free of charge. I thought it was a bargain. Ten years later I traveled to the Galapagos for the first time, leading a photography tour of my own. Since then I have explored the islands on 13 separate trips. I owe much of my overall understanding of and appreciation for the Galapagos to Michael's stimulating book.

In the past 25 years in my studies on the Galapagos Islands, I spent hundreds of wonderful hours reading the scholarly words of scientists and writers as they methodically disclosed the mysteries of this fascinating cluster of islands. These dedicated men and women often work under difficult conditions,

driven by their quest to understand the natural world and the fascinating wild creatures that live in it; I am indebted to them all for helping me to understand the science of the Galapagos. I am equally grateful to a number of Ecuadorian naturalists whose knowledge and genial personalities made my visits more informative and enjoyable. Among them are Juan Carlos Naranjo, Jimmy Iglesias, Bitinia Espinoza, Jonathan Green and Billy Dean Miquelon.

This is my eighth publication with the friendly, capable folks at Firefly Books. As before, it was a pleasure to work with them. I owe special thanks to publisher Lionel Koffler, editor Michael Mouland, copy editor Gillian Watts and designer Kimberley Young.

Overall, this is my 61st book, and for the 61st time I dedicate it to the most deserving person in my life — my wife of 42 years, Aubrey Lang. She is still the most interesting, stimulating, loving, compassionate, unselfish person I know. I love her dearly.

The Sally Lightfoot crab **(above)** can grip a rock so tightly that only the strongest waves can wash it free. The turquoise waters and white sand beach make Gardner Bay **(opposite page)** a popular tourist destination on Espanola Island.

Introduction

My first memory of the Galapagos Islands, from some 25 years ago, still brings me great joy to recall. That morning, as I left the security of our boat and stepped into

a small, wobbly rubber Zodiac to go ashore, a triangular gray fin etched a silver line across the ocean surface beside me. Through the dark water I clearly recognized the distinctive head of a hammerhead shark. Having suffered all night with terrible seasickness, I was desperate to land on Genovesa Island, but I felt quite uneasy with this toothy predator just arm's length away from our flimsy rubber boat.

Within moments of landing on the sandy shore, the wildlife spectacle that greeted me flushed away all my fears and queasiness. A pair of elegant swallow-tailed gulls were whistling and courting, oblivious to me and the rapid clicking of my camera. Nearby, a young sea-lion pup, milky tears staining its cheeks, barked once or twice, then flopped back

onto the sand to snooze. Overhead, a silent squadron of black angels floated in the breeze. These were no heavenly spirits but the drifting maneuvers of romantically hopeful frigatebirds. Our small group of nature lovers had landed next to a nesting colony of these birds, and their breeding season was in full swing. Several rival male frigatebirds, their red throat pouches inflated as big as grapefruits, sat perched on knee-high bushes, peering intently into the sky. When a white-throated female sailed overhead, all the males launched into their best song-and-dance routine. Rocking from side to side, they rapidly vibrated their wingtips, excitedly imploring skyward with a loud, quivering chatter. They were desperate to attract a partner, but female frigatebirds are

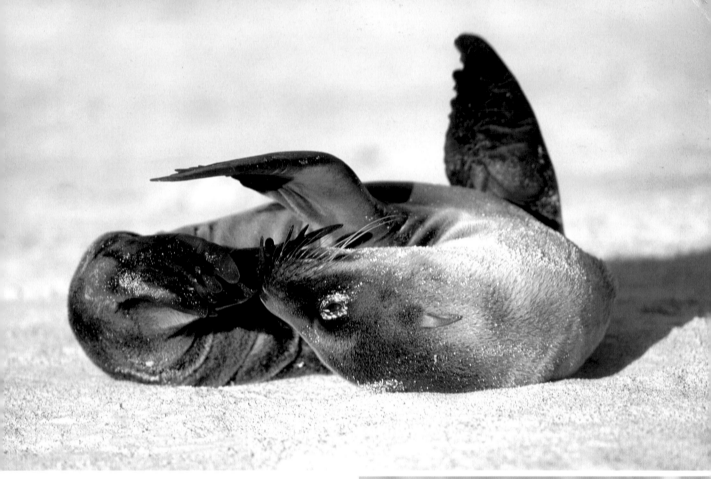

very discerning, searching for qualities only they can detect. In the words of the jazz legend Duke Ellington, "It don't mean a thing if you ain't got that swing," and so it must be for frigatebirds as well. Hours later, after we had left this enchanting island, I replayed those delicious moments over and over again in my head as I rolled and tossed in my bunk that night. No matter how miserable my queasiness made me feel, I wouldn't have changed a thing.

In 1979 the Galapagos Islands were one of the earliest World Heritage Sites to be established by UNESCO (United Nations Educational, Scientific and Cultural Organization), a designation intended

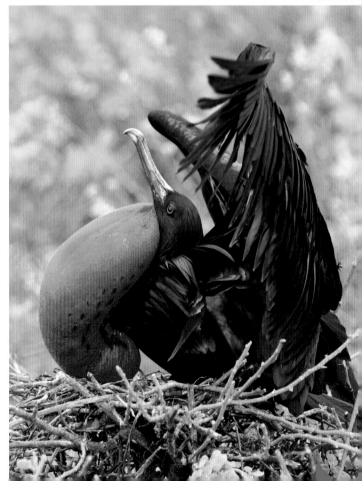

(Top) Between nursing periods, a Galapagos sea-lion pup may spend much of its time alone on the beach. **(Right)** The intense color of the male great frigatebird's throat pouch is an honest signal of health and vitality. **(Opposite page)** The single egg of the swallow-tailed gull is incubated by both parents.

to protect and preserve sites of cultural and natural heritage around the world. Today there are more than a thousand World Heritage Sites, and the Galapagos Islands are one of the most widely valued. No one goes to these enchanted islands to ogle architectural splendor, admire ancient stone ruins or absorb colorful native culture. They go instead to savor the unique flora and fauna and to reflect on the power of evolution by natural selection, one of the most important ideas in all of science.

I have been fortunate to travel to many of the wildlife-rich areas of the world and I am often asked which is my favorite. My answer is always the same. If you are a critter junkie like me and thrive on the wonders of the world's wildlife, there are four destinations you should add to your bucket list: the breathtaking wildebeest migration on the Serengeti Plains of East Africa; the austere beauty of the Svalbard Archipelago in the Norwegian Arctic, a haunt of polar bears and walruses; the island of South Georgia in Antarctica, with its indescribable throngs of penguins; and the celebrated Galapagos Islands, the subject of this book.

The biology of the Galapagos Islands has arguably been studied more than any other archipelago in the world. It's no surprise that there are countless stories to be told, and doing them justice would require a text many times longer than I wish to write, or than you would find interesting to read. As a compromise, I have chosen my personal favorites — the greats of the Galapagos, so to speak. After working in ecotourism for nearly four decades as a naturalist leader and lecturer, I have learned what kind of information people like to hear. In *Galapagos: A Traveler's Introduction*, I discuss many different animals, plants and natural processes, but I emphasize just two or three aspects of each that I find particularly fascinating. My hope is to excite readers about the wonders of these islands and to whet their appetite to know more.

After a morning fishing trip a brown pelican will often roost on the shoreline to preen its feathers.

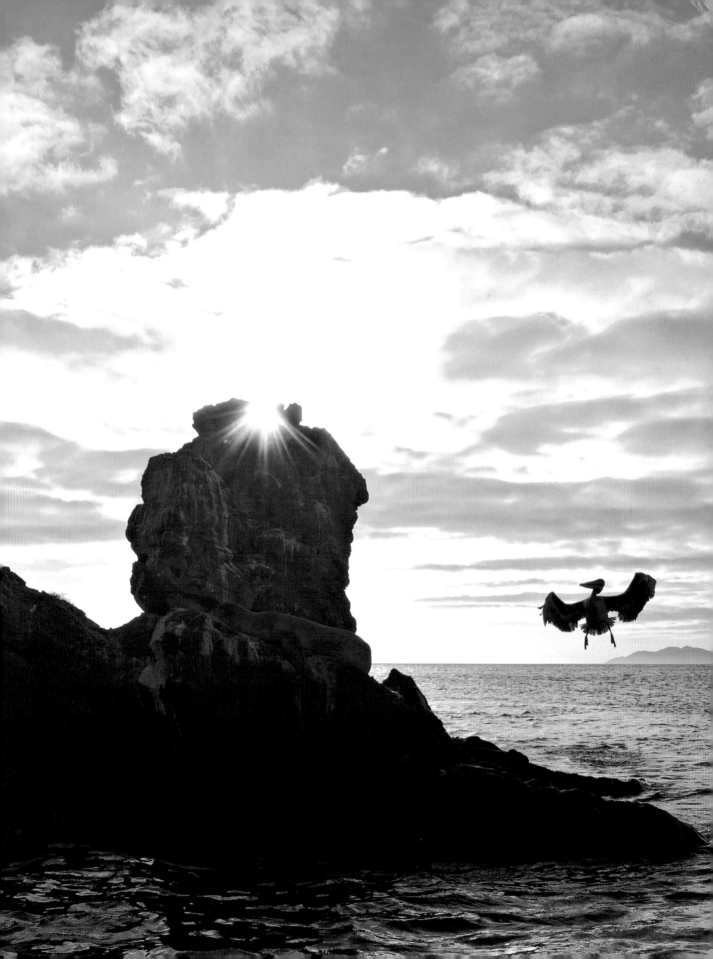

Blue-footed boobies are visual hunters and start fishing
as soon after sunrise as the light levels permit.

How Islands Pop Up

Sailing in their clumsy wooden ships, captains of old found the shifting winds and unpredictable currents surrounding the Galapagos Islands a challenge to navigate.

Some believed that the islands drifted about, appearing and disappearing in mysterious ways. The most superstitious of sailors called the islands enchanted or bewitched. Modern mariners laugh at such old-fashioned beliefs, but the scientific truths about the islands are even more wondrous than the legends of earlier times.

The Galapagos Islands straddle the Equator in the eastern Pacific Ocean, some 1,000 kilometers (620 mi) from Ecuador. If you could magically drain away all the water in the ocean, you would find the islands at the intersection of two underwater mountain ridges. One of these, called the Cocos Ridge, runs in a northeasterly direction for roughly 1,200 kilometers (746 mi) until it eventually collides with the country

of Panama in Central America. The other, called the Carnegie Ridge, runs directly east and eventually bumps into South America at Ecuador. Both of these submarine ridges yield important clues to the history of the Galapagos Islands, and in a moment they will become important pieces of the story.

The landmass of the Galapagos Archipelago covers a relatively small area, roughly 8,000 square kilometers (3,090 sq mi), which is about a third larger than Canada's Prince Edward Island but only half the area of the Hawaiian Islands. The archipelago comprises thirteen large islands, six small islands and more than a hundred tiny islets and exposed rocks. Isabela, at the western edge of the archipelago, is the largest island, making up roughly 60 percent of the

total land area of the Galapagos. Fanciful mapmakers like to say that the shape of Isabela reminds them of a seahorse; as it turns out, one species of seahorse actually lives in the equatorial waters of the islands.

All the islands in the Galapagos arose from the molten mouths of underwater volcanoes. Most of the islands were formed by one or two volcanoes, but Isabela arose from six separate ones. From space, Isabela's volcanoes can clearly be seen along the spine of the island. Each of them is shaped like an

The Galapagos Islands sit on a submerged shelf that raises them well above the surrounding ocean depths. **(Opposite page)** The profile of La Cumbre Volcano on Fernandina Island is a textbook shield volcano.

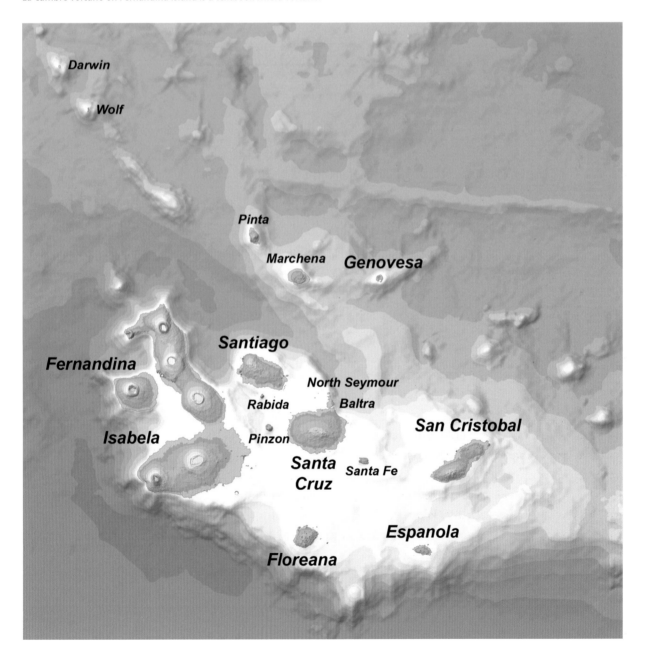

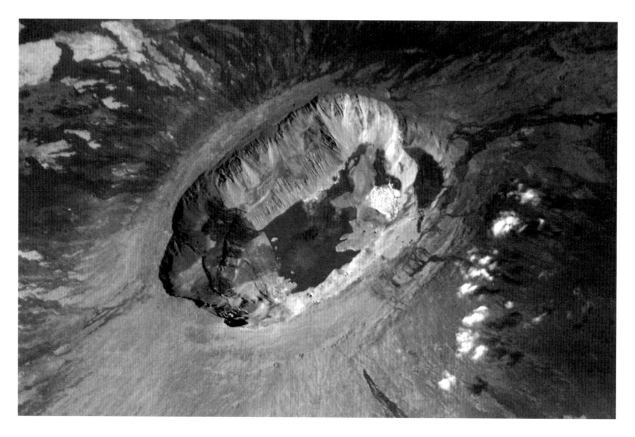

La Cumbre Volcano on Fernandina Island erupted most recently in April 2009.

overturned soup bowl, with steep sides and a flat top, and at the summit is an immense caldera — a craterlike depression formed when the core of a volcano collapses. The caldera atop Isabela's Volcán Sierra Negra is the second-largest caldera in the world at around 10 kilometers (6.2 mi) in diameter.

Continents That Drift

To understand the origins of the Galapagos Islands it is helpful to review the science of two important ideas, continental drift and seafloor spreading. These ideas may be new to you but they explain some of the ways in which our planet grows and changes. The Earth's crust is not a continuous covering of rock like the peel on a juicy orange. It's more like a jigsaw puzzle, made up of many different pieces called *tectonic plates*. Heat, leaking from the core

of the Earth, causes these plates to shift and move around in the same way that stray leaves do on the surface of a hot cup of tea. This process, aptly named *continental drift*, was unknown when I was a boy; it has since been a great help to scientists in understanding why most volcanoes occur where they do.

As you can see from the accompanying illustration, the edges of tectonic plates do not necessarily coincide with the boundaries of continents. Many tectonic plates include large areas of land as well as sections of ocean floor. For example, the North America Plate, containing Canada and the United States, extends to the middle of the Atlantic Ocean, roughly 2,900 kilometers (1,800 mi) from the coastlines of Newfoundland and Nova Scotia. When we look at the Galapagos Islands, the two important tectonic plates to consider are the Nazca Plate and

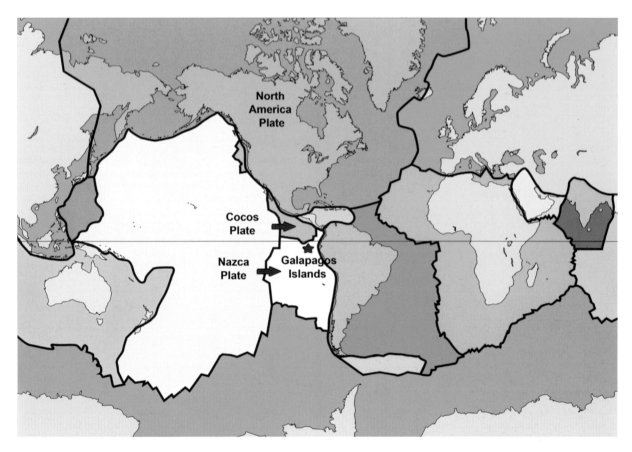

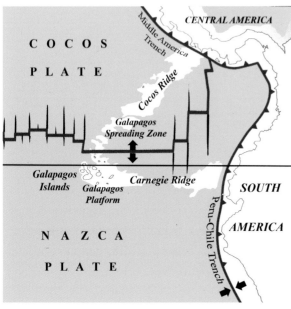

The Galapagos Islands sit on the northern edge of the Nazca Plate near its junction with the Cocos Plate.

the Cocos Plate. The islands are located close to the northern edge of the Nazca Plate, near its boundary with the Cocos Plate.

Tectonic plates are in constant motion, shifting position and continually bumping into each other. Since the plates are rigid, all the action occurs along their edges, at the boundaries between neighboring plates. In this continual bumping and grinding, slipping and sliding, plates behave mainly in one of three ways: they move apart, collide or slide past each other.

The boundary running between the Cocos and Nazca Plates, just north of the Galapagos Islands, provides a good example of plates moving apart. Along this seam in the Earth's crust, molten rock from deep inside the planet floods to the surface, cools and hardens, welded to the edges of the plates on either side. The newly formed ocean crust moves

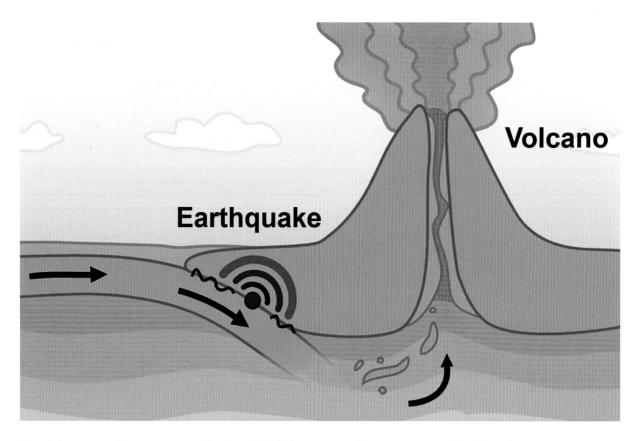

Earthquake

Volcano

At a subduction zone, denser oceanic crust slips beneath the lighter continental crust, generating earthquakes and volcanoes.

apart in a continual conveyor-belt fashion, a process called *seafloor spreading*.

Since new crust is continually being formed in some areas, there have to be places on Earth where crust is being consumed — otherwise the planet would gradually grow bigger. The places where crust disappears are called *subduction zones*. A good example of a subduction zone runs along the west coast of Central and South America. There the edges of the Cocos and Nazca Plates are slowly being eaten away. In the case of the Nazca Plate, as it drifts slowly eastward it also slips beneath the South American Plate, folding, fracturing and eventually melting. As one tectonic plate disappears beneath another like this, the grinding plates produce earth-trembling quakes and the melting rock bubbles up as angry volcanoes. This explains why a chain of destructive

volcanoes runs along the entire western coastline of Central and South America, and why the area is so frequently rocked by devastating earthquakes.

Hotspots: The Fiery Mouths of Earthly Dragons

So, how do you explain the volcanoes in the Galapagos? The islands are too far from the subduction zone along the west coast of South America for that to be the source. It turns out that, although the vast majority of volcanoes occur near subduction zones, not all of them do, and the Galapagos is a good example of this. Scattered around the planet are some 45 so-called *hotspots* — small, localized weak spots in the Earth's crust where magma breaks through to the surface and a volcano is born. Hotspots are not related to the boundaries of tectonic plates and occur

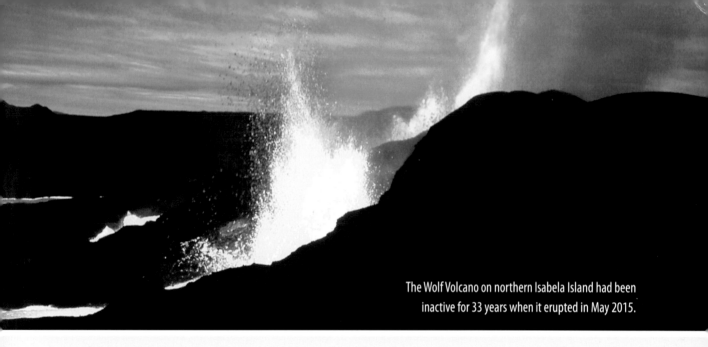

The Wolf Volcano on northern Isabela Island had been inactive for 33 years when it erupted in May 2015.

A Brush with Death

In 1825 Captain Benjamin Morrell, on an expedition to hunt fur seals, described an eruption on Fernandina that almost ended in disaster for him and his crew:

> At two o'clock, A. M. … our ears were suddenly assailed by a sound that could only be equalled by ten thousand thunders bursting upon the air at once; while, at the same instant, the whole hemisphere was lighted up with a horrid glare … The heavens appeared to be in one blaze of fire, intermingled with millions of falling stars and meteors; while the flames shot upward from the peak of Narborough [Fernandina] to the height of at least two thousand feet.

Shortly after four in the morning, "the boiling contents of the tremendous caldron had swollen to the brim, and poured over the edge of the crater in a cataract of liquid fire. A river of melted lava was now seen rushing down the side of the mountain."

Even though Morrell's ship was 16 kilometers (10 mi) from the volcano, the heat was so great that the tar sealing the seams of the wooden ship began to melt and dripped from the rigging.

> Our situation was every hour becoming more critical and alarming. Not a breath of air was stirring to fill a sail, had we attempted to escape … All that day the fires continued to rage … The mercury continued to rise until four, P. M., when the temperature of the air had increased to 123° [50.5°C], and that of the water to 105° [40.5°C]. Our respiration now became difficult, and several of the crew complained of extreme faintness.

Morrell was worried that he and his crew would surely perish. Thankfully, a breath of wind finally stirred his sails and he immediately attempted to flee. But his path brought him closer to the volcano. At one point the air temperature climbed to 64°C (147°F) and the water temperature to 66°C (150°F). Morrell wrote: "I became apprehensive that I should lose some of my men, as the influence of the heat was so great." The limping ship finally escaped. Eighty kilometers (50 mi) away, the raging volcano continued to shoot "its vengeful flames high into the gloomy atmosphere, with a rumbling noise like distant thunder."

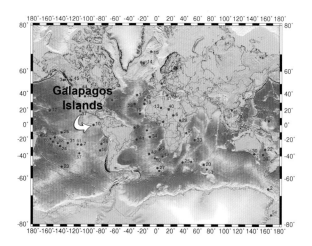

Scientists have identified at least 45 geological hotspots **(top)** on the planet. Rivers of liquid lava may flow at many kilometers per hour, easily overtaking a fleeing giant tortoise **(bottom)**.

beneath oceanic crust as well as continental crust. The Galapagos hotspot is the source of the volcanoes that created all the islands in the archipelago, like the mouth of a fiery dragon that periodically spits out molten rock from the planet's core.

The last eruption in the Galapagos was in May 2015, when the Wolf Volcano, on the northern tip of Isabela Island, put on a spectacular display. In the past 200 years there have been roughly 60 separate eruptions in the Galapagos Islands, the majority on

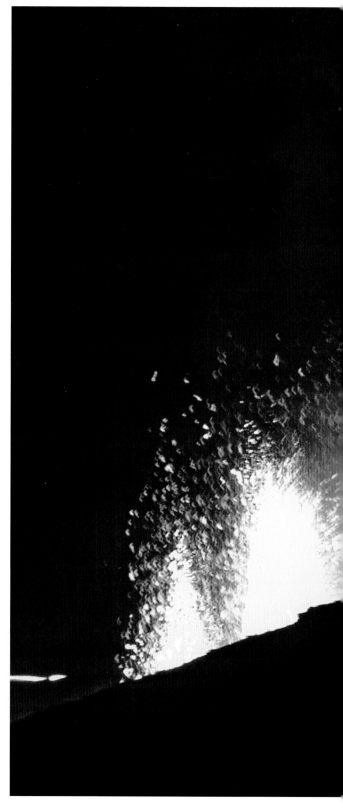

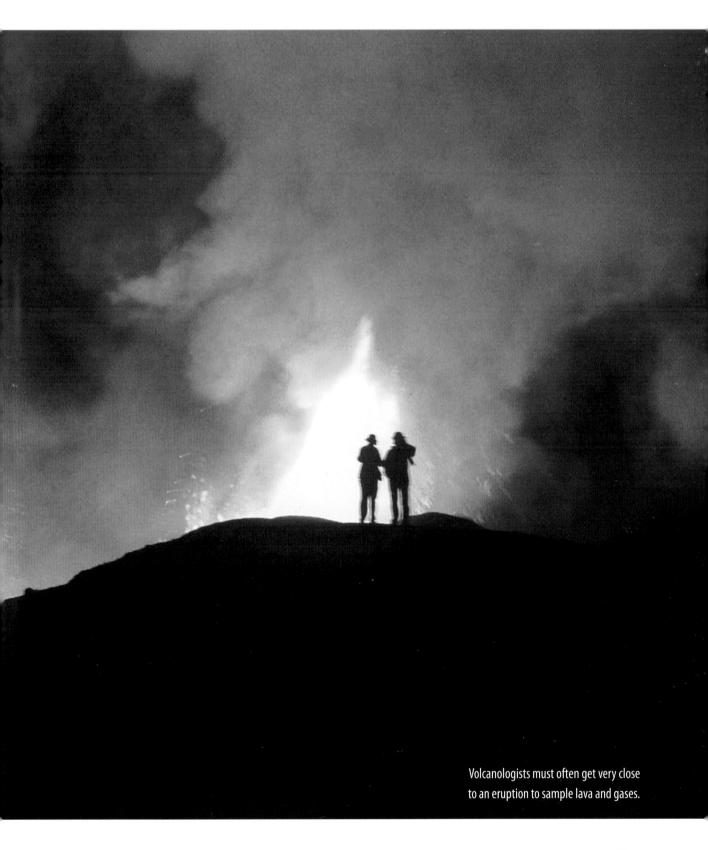

Volcanologists must often get very close
to an eruption to sample lava and gases.

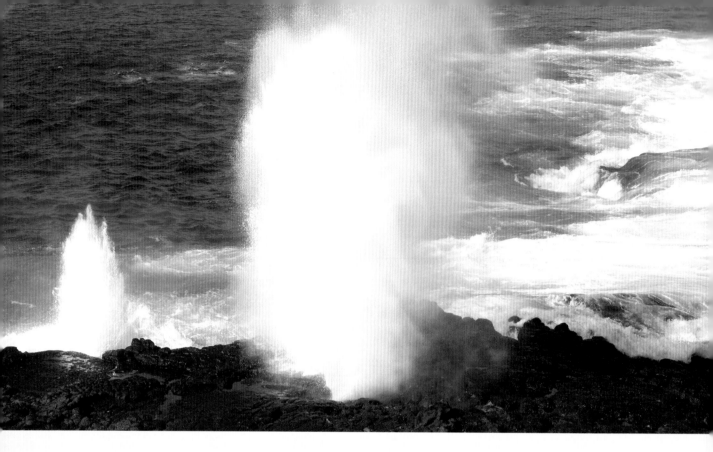

When the tide and sea conditions are right, a spectacular blowhole **(above)** can be seen along the western shore of Espanola Island. The pounding power of the sea is slowly eroding the coastline **(below)** of every island in the Galapagos Archipelago.

Stationary Hotspot + Rafting Plates

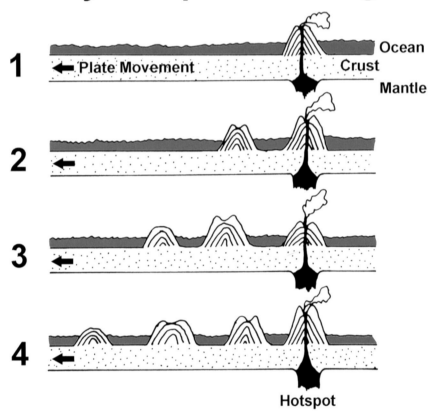

Isabela and Fernandina, the two most westerly of the large islands. These periodic eruptions sometimes generate towering plumes of ash, as tall as a skyscraper, as well as deadly rivers of fast-flowing blistering-hot lava that can engulf a slowpoke tortoise or a loafing lizard and instantly turn it into a crispy critter.

Islands on the Move

Normally a hotspot stays in one place. As a tectonic plate drifts over it, a chain of volcanoes is produced, which is exactly what happened in the Galapagos Islands and is still happening today. The Galapagos hotspot is currently beneath the western part of the archipelago. As the Nazca Plate slowly drifts toward South America at roughly 4 centimeters (1.5 in) a year — the speed that healthy human fingernails grow — older islands are "rafted" to the east. Because of the hotspot's location, the youngest islands in the Galapagos are in the west and the oldest in the east. Scientists estimate that Fernandina and Isabela Islands are geological teenagers at 700,000 years old, Santa Fe Island is a middle-aged 2.7 million years old, and Espanola Island is a young senior citizen at 3.2 million years of age.

Once an aging volcano drifts beyond the reach of a hotspot and ceases to erupt, it immediately begins to disappear as the local weather starts destroying it. It seems hard to believe, but plain ordinary water —

in the form of pelting rain and pounding surf — is the attacker that erodes the land. The volcano's fate is inescapable. Eventually, after thousands to millions of years, the lofty mountain of lava is slowly chiseled away and disappears beneath the waves, where its destruction continues until nothing is left. That is how a volcano dies.

So how old are the Galapagos Islands? Are they simply the age of the oldest visible rocks, 3.2 million years, or are they older? Geologists think that the Galapagos hotspot may have existed for tens of millions of years, perhaps as long as 80 to 90 million years. The evidence for this is the existence of the Cocos Ridge and the Carnegie Ridge, which I mentioned earlier. Both are submarine mountain chains that stretch to Central America and South America,

following the ancient paths of their respective plates. Thus the evolution of the unique life forms on the islands didn't necessarily happen in a mere 3 to 4 million years, but may have occurred over tens of millions of years. All the Galapagos Islands we know today will eventually vanish and be replaced by newer ones. But the unique animals and plants of the islands will likely not disappear; they will simply jump to the new islands, like rats fleeing from a sinking ship.

The marine iguana **(below left)** and the land iguana **(below right)** evolved from the common iguana **(opposite page)** perhaps 11 million years ago, as much as 7 million years before the current islands in the Galapagos existed.

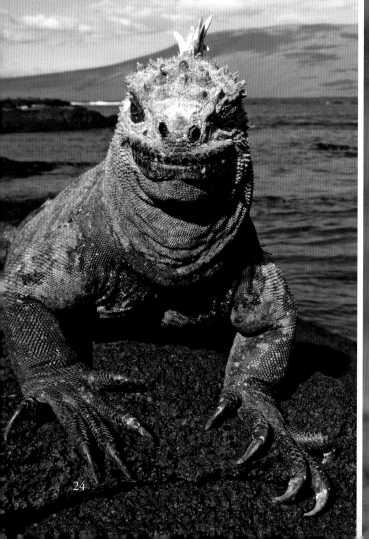

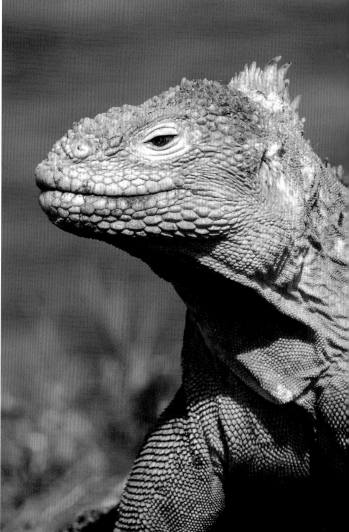

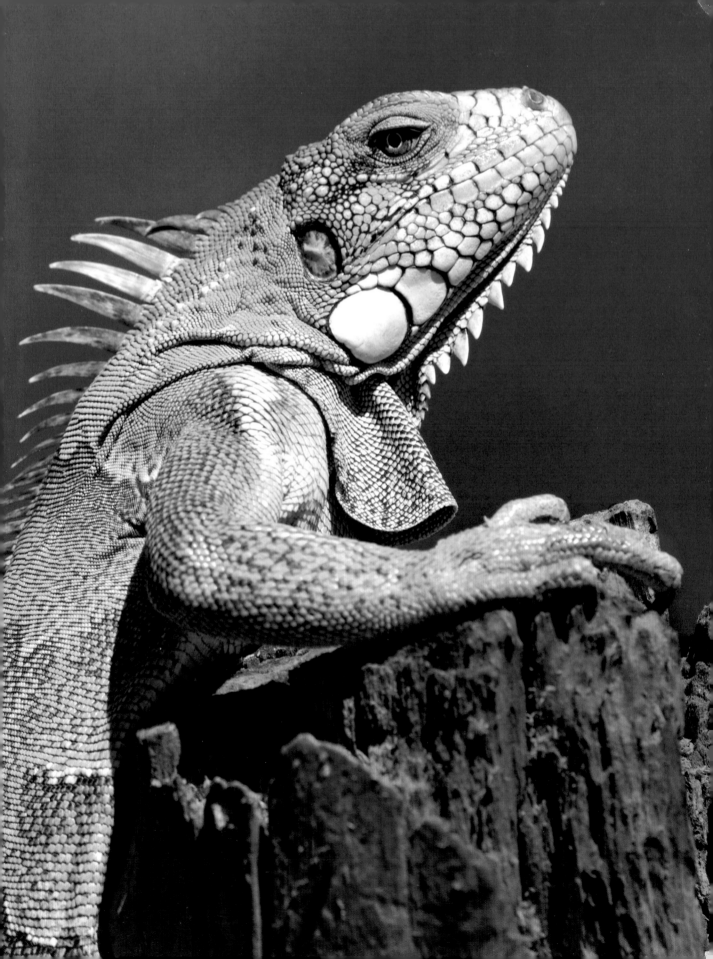

Island Life

Before I fly to the Galapagos Islands from mainland Ecuador, I often take a side trip to the country's rainforests, one of the biologically richest forests in the world.

Here there are more different kinds of trees in an area twice the size of a football field than there are in all of Canada. On a recent stopover to this fascinating forest, I watched a beautifully camouflaged red-tailed boa constrictor catch a startled blue-headed parrot as the bird was distracted at a clay lick. Later that same day I watched a dozen sulfur and blue butterflies flutter around the head of a river turtle, intent on sipping the reptile's salty tears. And as the sun was setting, a giant otter clenching a piranha in its teeth swam past my canoe, followed by a noisy, hungry pup. As always on such visits there was heat, humidity and heavy rainfall. A few days later when I landed in the Galapagos Islands, at almost the same equatorial latitude, I was greeted by a thirsty world of

brown, gray and black, cloaked in a chilly mist. How could two areas at the same latitude be so different?

Ocean currents and trade winds control the islands' year-round climate and generate two contrasting seasons. The cool/dry season, from June to November, has typical daytime temperatures below 24°C (75°F). It is referred to locally as the garua season, when a fine, cool mist frequently blankets the tops of the loftier islands but there is little or no actual rainfall in the lowlands. During these dry months, trade winds blowing from the southeast bring to the islands the cold Humboldt Current from South America. The chilly current drives down the water temperature to 18° to 22°C (64° to 72°F). In the 1600s, "shiver me timbers" was a common

expression used by Galapagos pirates to convey a feeling of shock or surprise, and I can tell you that snorkeling in such cold water without a wetsuit will certainly shiver your timbers! But this injection of cold, oxygen-rich waters benefits fish and other marine life and, as a result, sea lions and seabirds thrive.

The contrasting season is the warm/wet season, which typically comes between December and May. During these months the northeasterly trade winds dominate, drawing in the warm equatorial waters of the Panama Current. This results in warmer air temperatures of up to 30°C (86°F) and frequent showers, usually as daily afternoon rainstorms. Water temperatures also increase substantially, rising to 25°C (77°F). The warm temperatures and rainfall cause a flush of green over the land, and vegetation everywhere flowers and goes to seed. The resulting insects and seeds are a bonanza for the land birds, such as Darwin's finches, and they prosper as a consequence — some well-fed finches may raise two or three families in succession. Not surprisingly, the warm/wet season is a popular time for tourists to visit. The sunny skies and warm water offer an appealing escape from the snow and cold of northern winters.

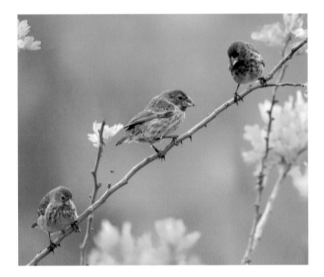

Darwin's finches **(left)** may hatch up to six eggs in a clutch. The humpback whale **(below)** is just one of the two dozen cetaceans that frequent the waters of the Galapagos Archipelago.

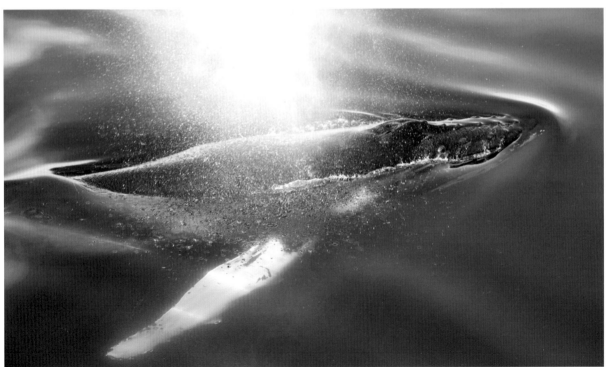

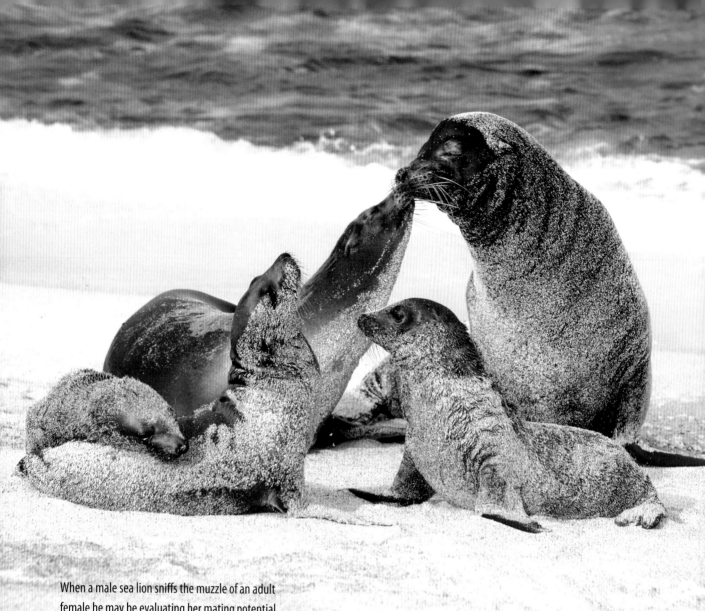

When a male sea lion sniffs the muzzle of an adult female he may be evaluating her mating potential.

The Menace of El Niño

In some years — called El Niño years — unusually warm waters flood the archipelago from the western Pacific. The result is greater rainfall, sometimes with terrific thunderstorms and flash flooding. Air temperatures rise and the ocean gets warmer, rising to 31°C (88°F). The impact of this on the flora and fauna can be dramatic, and sometimes deadly. Thick vegetation can overrun the islands, providing more food for land birds, whose populations explode. With the living so easy, Darwin's finches may raise eight families of chicks in a row. Meanwhile, however, the warm water causes desertion and death among seabirds, marine iguanas, sea lions and fur seals.

 El Niño events occur every three to seven years and last from six to eighteen months. The worst El Niño on record occurred in 1982–83, when the sea lion population dropped by a third and 70 percent of the marine iguanas starved to death.

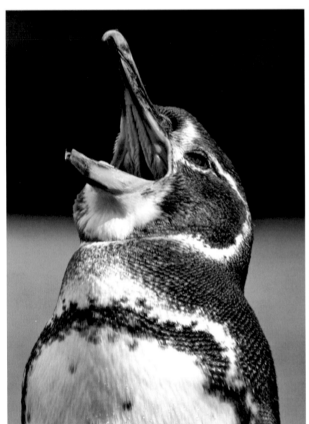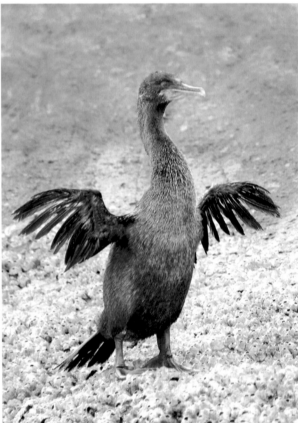

Both the Galapagos penguin **(above left)** and the flightless cormorant **(above right)** are endemic species found nowhere else in the world.

A third influential ocean current deserves to be mentioned. The deep, cold Cromwell Current originates in the west and flows toward the islands along the Equator. If you drained away the ocean waters as we imagined before, you would clearly see that the entire western edge of the archipelago forms a sheer wall that drops steeply into the ocean depths. When the deepwater Cromwell Current collides with this wall, cold, oxygen- and nutrient-rich waters are flushed to the surface and marine life thrives as a result. The Cromwell upwelling is especially beneficial to whales and seabirds.

Two species of seabirds, the Galapagos penguin and the flightless cormorant, rely heavily on the cold, rich waters of the Cromwell Current. These seabirds survive as small, localized populations that occur no-

where else in the world. Because they are extremely sensitive to changes in water temperature, they are highly vulnerable to the effects of global warming.

Patterns of Plant Life

Throughout the world, two major climate factors, temperature and rainfall, determine which plants take root, grow and cover a landscape. These two variables govern whether an area will become desert, rainforest, grassland, temperate forest or a landscape of pines and spruces. In the Galapagos Islands, annual temperatures range between 15° and 29°C (59° to 84°F) — not the searing temperatures you might expect on the Equator. In fact, the world's hottest temperatures actually occur in deserts that cluster around the latitudes of 30 degrees north and south,

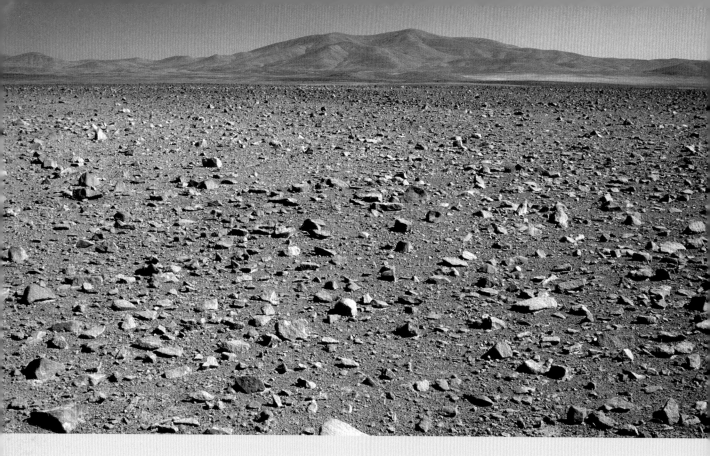

The hot and extremely arid Atacama Desert **(above)**, like most deserts, is not located over the Equator as you might expect. The coastal zone in the Galapagos varies from bare lava **(opposite, top)** to sandy shores **(below)** and mangrove thickets **(opposite, bottom)**.

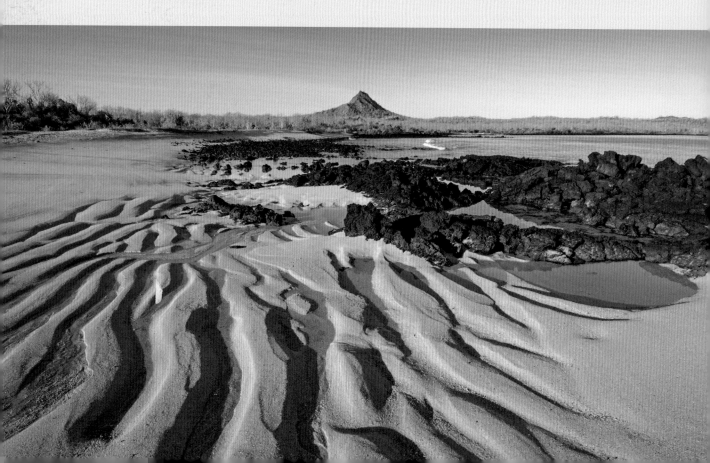

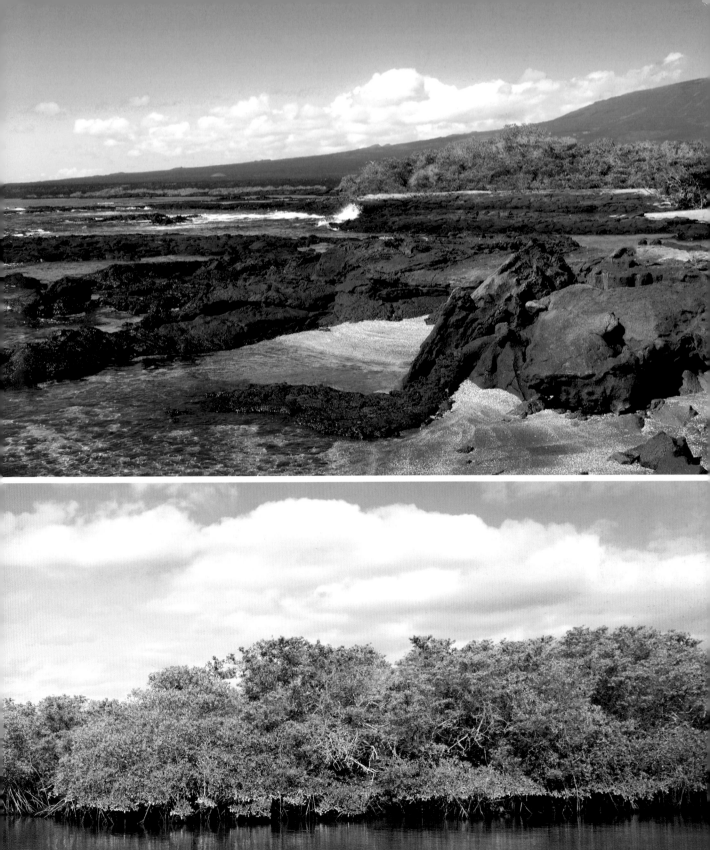

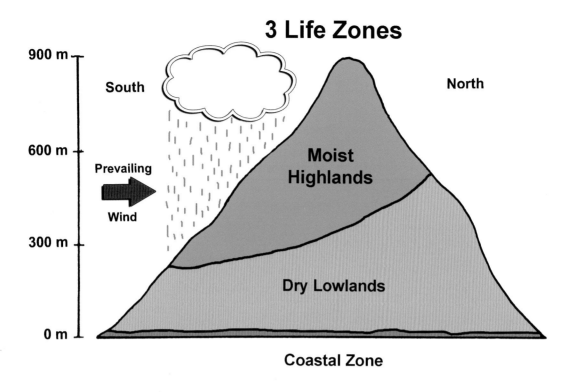

3 Life Zones

900 m

South

North

600 m

Prevailing

**Moist
Highlands**

Wind

300 m

Dry Lowlands

0 m

Coastal Zone

The island landscapes can be broadly broken down into three vegetation zones.

not in areas that straddle the Equator.

Rainfall in the Galapagos fluctuates from year to year. It also varies from island to island, depending on where the island is located within the archipelago and whether it is mostly flat or elevated. Annual rainfall amounts range from a parched 8 centimeters (3 in) to a soggy 150 centimeters (59 in). During the El Niño event of 1982–83 some of the islands were swamped by more than 5 meters (16 ft) of rain. In reality, climate in the Galapagos Islands swings between two extremes: drought with scanty rainfall or dramatic flooding in El Niño years. In response to the climate, the island landscapes can be broadly broken down into three recognizable vegetation zones: a coastal fringe, the dry lowlands and the moist highlands.

The coastal zone is found on all the islands. It's usually quite narrow, sometimes only a few meters wide. It can consist of great stretches of barren black lava; soft, sandy beaches, some with small rolling dunes; or tangles of mangrove trees in sheltered bays. Any plants that edge the shoreline are necessarily hardy and tolerant of the salty conditions.

Crabs of several species are conspicuous critters along every coastal fringe. Certainly the showiest of the bunch is the Sally Lightfoot, so named because it can dart with remarkable speed in any direction. This photogenic crab is strikingly colored in bright orange and red with an electric-blue belly, like the way you might expect a child in kindergarten to imagine how a crab should look. These fleet-footed crabs are seen along most shorelines, sometimes in small armies of scuttling legs and plucking pincers. When the tide retreats, they nimbly forage on the carpets of slippery algae that grow on the rocks, also feeding on any carcasses that float ashore. These

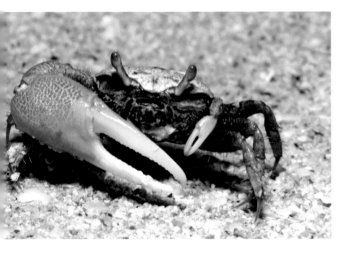
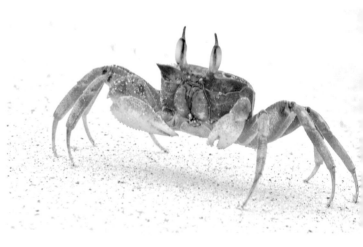
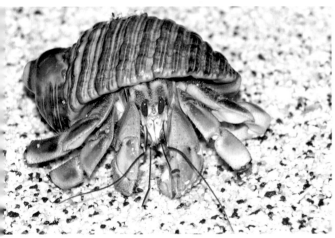
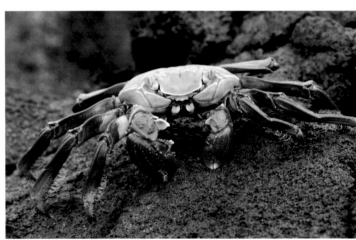

The male fiddler crab **(top left)** uses its enlarged front claw to advertise its rank. When the tide retreats, the ghost crab **(top right)** emerges from its sandy burrow to feed on algae. As it grows larger, the hermit crab **(bottom left)** must find a new abandoned shell to occupy. The Sally Lightfoot crab **(bottom right)** rarely interacts with other shoreline crab species.

flashy crabs boldly climb over marine iguanas, searching for juicy ticks on the reptiles' scaly backs, while the lizards barely seem to notice or care.

You may wonder why Sally Lightfoots are so colorful. Some male animals use bright coloration to attract female partners, but Sally Lightfoot females are as colorful as the males. In some cases animals use elaborate colors and patterns to warn predators that they are poisonous or distasteful. If this is the crab's purpose, the strategy is a failure, since they are readily eaten by various shorebirds and herons, including the lightning-necked lava heron, which relies on its black plumage to camouflage its movements and allow it to sneak closer. In the end, the reason for the Sally Lightfoot's coloration remains a mystery.

The Cactus Kingdom

The dry lowlands form the largest vegetation zone in the Galapagos. They are found on all of the islands, and on some of the smaller flat ones they completely cover the island. This is the zone that every tourist visits and where they spend most of their time.

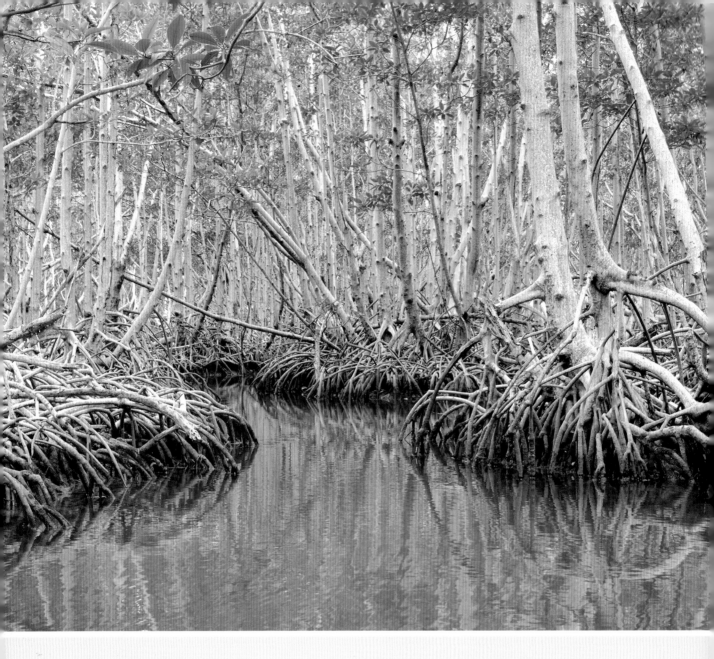

Mangroves

Because of their mosquitoes, mud and smell of rot, mangroves are forests that nobody likes, yet they are one of the most biologically productive ecosystems in the world. Mangroves are a group of tropical trees uniquely adapted to life in the intertidal zone, which is alternately baked by the equatorial sun and flooded by seawater twice each day. Mangroves grow where no other trees can, and they do it with specialized roots that grow above the mud, leaves that can expel damaging excess salt, and tough seedlings that can float for months and carry the plants to every tropical coastline in the world.

In the Galapagos Islands, the quiet bays and inlets where mangroves grow are important refuges for many kinds of wildlife. They are a vital nursery for different fishes, a mating area for green sea turtles, a birthing place for reef sharks, a nesting area for herons and pelicans, and a feeding area for hungry penguins.

The most noticeable plants in the dry lowlands are palo santo trees and spiny cactuses. The palo santo — its name means "holy wood" — is a medium-sized tree that quickly sprouts leaves when it rains, then drops them and looks gaunt and lifeless throughout the dry season. The palo santo is related to frankincense and myrrh, which in the Christian Bible were valued gifts brought by three wise men to the newborn baby Jesus. In South America the elevated status of the palo santo dates back to the time of the Incas. The fragrant wood was burned like incense, and shamans claimed that the rising smoke would chase away evil spirits and bring good fortune. Today bark shavings are still burned for the pleasing odor they produce.

Everyone can recognize a cactus, but some in the Galapagos are as big as trees and like none anywhere else. Cactuses are juicy plants that store moisture in their stems and whose leaves have evolved into sharp spines, designed to reduce water loss and defend the plant. In the islands there are three groups of cactuses: the lava cactus, the candelabra cactus and prickly pear cactus, of which there are six different species.

The lava cactus, the smallest of the Galapagos cacti, is found only on barren lava fields, where the sun can heat the rock up to 50°C (122°F) — hot enough to fry an egg. This hardy cactus consists of a cluster of short, spiny tubes that sprout from narrow cracks in the otherwise lifeless lava. The candelabra cactus often grows in the same lava fields, but with its multiple jointed arms up to 8 meters (26 ft) tall, it is a giant by comparison.

To conserve moisture, the palo santo tree loses its leaves during the dry season.

Typically, the flowers of the lava cactus **(below)** open before sunrise and usually shrivel within an hour or two. The candelabra cactus **(right)** can grow up to 8 meters tall. The large pads of the prickly pear cactus **(opposite page)** are not enlarged leaves but rather modified stems.

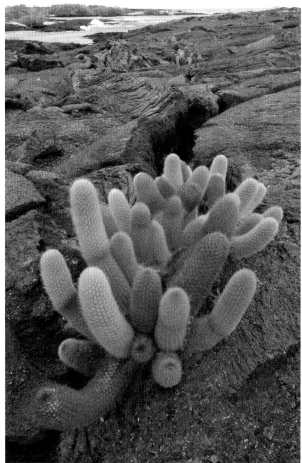

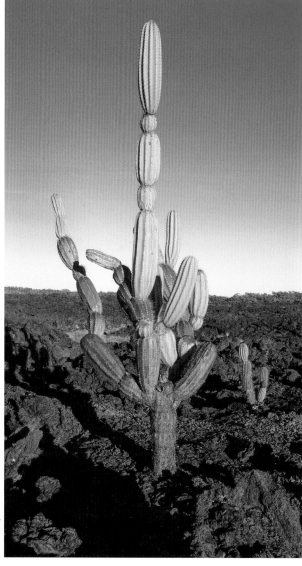

The rock stars of Galapagos cacti are the prickly pears. Some of these grow up to 12 meters (39 ft) tall and have massive trunks more than a meter (3 ft) in diameter. Like most cactuses, the prickly pear grows slowly; it may begin to flower only at 50 years of age and then live for another 150 years after that. Some prickly pears that are alive today may have been around when Charles Darwin, the islands' most famous visitor, scrambled ashore in 1835.

Scientists refer to the prickly pear cactus as a *keystone species*, a species on which other species greatly depend, so much so that if it were to disappear, the system would radically change and possibly collapse. Finches, mockingbirds and doves feed on prickly pear flowers, fruit and seeds, and the juicy pads are a major food for giant tortoises — many believe that tall prickly pears evolved in the Galapagos simply to outgrow the reach of hungry long-necked giant tortoises. The fruits, flowers and pads of the cactus are also essential food for land iguanas. When a ripe prickly pear fruit (the size of a date) falls to the ground, I have seen as many as three land

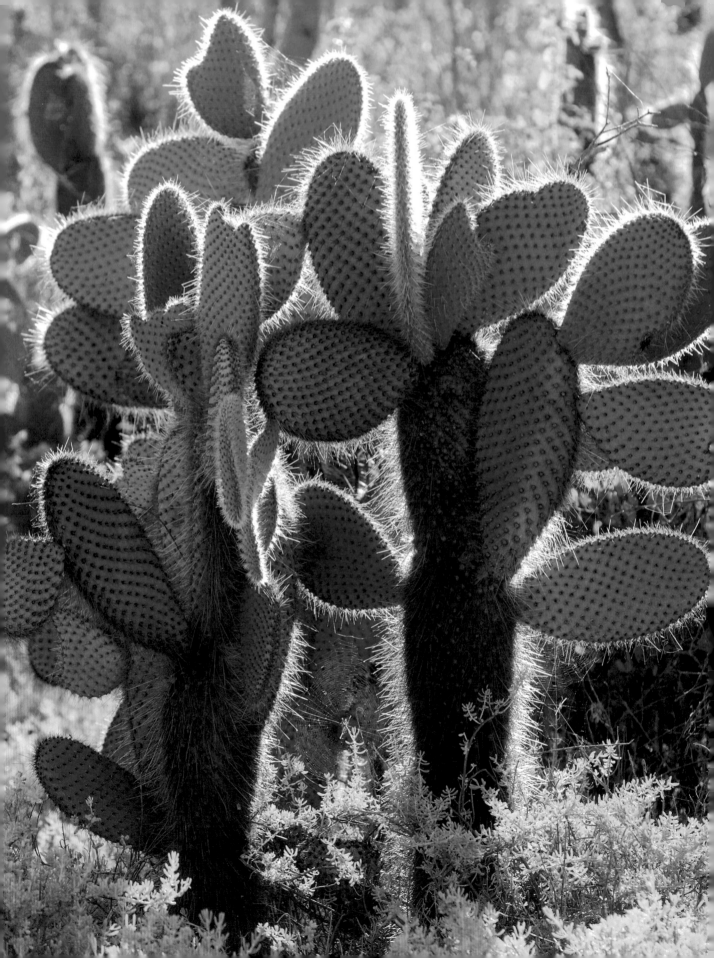

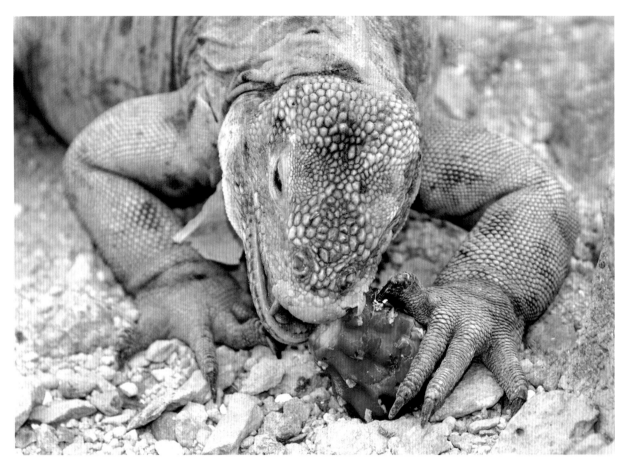

Before eating a cactus fruit, a hungry land iguana may first rub it on the ground to remove some of the sharp spines.

iguanas race over to eat it. Despite the sharp spines, the iguanas chew and swallow the fruit without any hesitation.

A Fairytale Forest

Moist uplands are less common than the drier areas and occur only on the taller islands, whose upper slopes are bathed in *garua* mist during the cool/dry season and intercept rain-filled clouds during the warm/wet season. As you would expect, this vegetation zone is often cool, damp and cloud-covered. The trees are stunted, their branches frequently covered by a shaggy coat of mosses, liverworts, ferns, lichens and even a few orchids. The upland forests look like the perfect setting for a fantasy movie in which a trio of witches stirs a bubbling pot of poisonous brew while a wizard waves around a magic wand.

Giant daisy plants that grow up to 15 meters (49 ft) tall are the dominant plants in the lush uplands. These treelike flowers are spindly, with multiple branches that create a leafy umbrella. The daisies belong to a genus of plants called *Scalesia*. There are 15 different species of *Scalesia*, and scientists believe that they all descend from a single ancestor that colonized the islands millions of years ago. This single colonist then split into many different species as it multiplied, spread and invaded different areas of the islands with slightly different moisture levels and temperatures. The story of how oceanic islands such as the Galapagos are initially colonized is the subject of the next chapter.

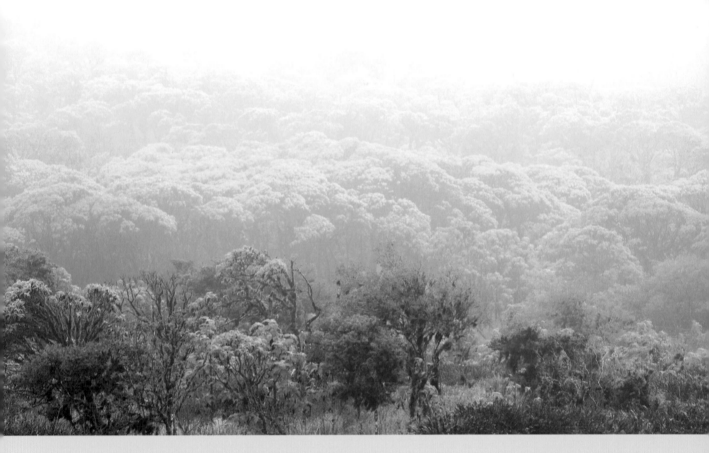

During the cool "garua" season, mists **(above)** may cloak the highlands all day long. The branches of the giant daisy plants **(below)** are often covered with epiphytic mosses and lichens.

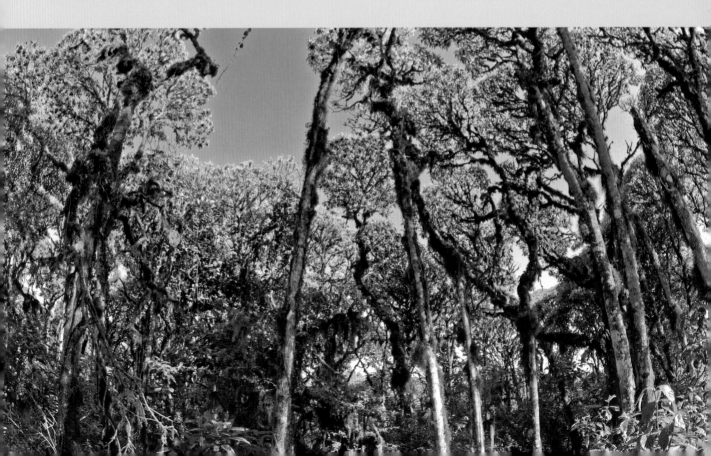

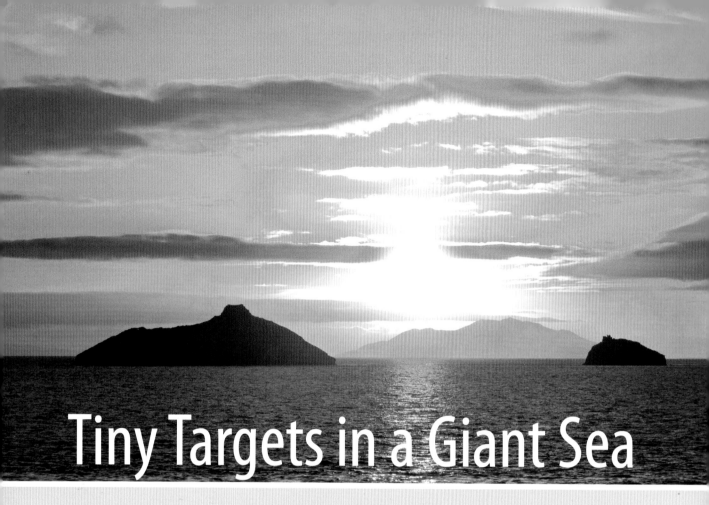

Tiny Targets in a Giant Sea

Before I started to study the Galapagos Islands I never thought much about how islands are colonized by plants and animals, and it turns out to be an unexpectedly

interesting process. The Galapagos are oceanic islands that arose from the repeated eruptions of underwater volcanoes. As with all volcanic islands, once the lava cooled, life had to settle on a landscape of barren rock. Today the islands boast a varied assortment of reptiles and seabirds but not a single amphibian or freshwater fish, and very few mammals. Biologists describe life on the Galapagos Islands as "unbalanced" — vastly different from Central and South America, where the majority of the colonists originated. How, then, did the Galapagos Islands acquire the unique mix of flora and fauna that they have today?

Think of the islands as a tiny target adrift in the vast eastern Pacific, a thousand kilometers or more from the nearest land. To get an idea of the challenge facing any animal or plant that might settle on these islands, imagine yourself sitting in the top row of a large football stadium. There is a grape lying on the ground in the middle of the field. It is too far away for you to see, but you must hit the grape with a dart. If you fail, you will die. Good luck!

For most successful colonists to the islands, it was indeed sheer luck that determined their fate. Many failed and perished. None of those successful animal pioneers were actively searching for the islands; all arrived by accident. Even so, for some colonists the odds were stacked in their favor — they were good long-distance travelers.

All the plants and animals that settled on the

islands arrived in one of three ways: by sea, by air or carried by wildlife. Plants that came by sea either had to float on their own or were carried on a raft of vegetation. Mangrove seeds are famous for their long-distance journeys by sea, and most tropical coastlines worldwide are rimmed by forests of mangroves. Four species grow in the Galapagos: red, black, white and button mangroves. All are tolerant of salt water and their fruit and seeds float, even if only for a limited time, allowing dispersal by ocean currents.

Charles Darwin was very interested in how plants disperse. After his visit to the Galapagos Islands in 1835, he spent several decades making experiments to learn how they do this. Once he started thinking about it, he couldn't stop; he had become obsessed with knowing. In one experiment he investigated how long seeds could stay alive inside the crop of a bird that had died at sea and then floated with the ocean currents. He discovered that they could survive for a month inside the bird, yet those same seeds would die after three or four days if they were dropped directly into seawater, unprotected.

Many plants have used wind power to colonize distant islands. Today the three most common plant groups in the Galapagos are lichens, grasses and ferns. All have very small, lightweight seeds or spores that can easily be carried by the wind. As well, all have seeds or spores that are resistant to the dry, freezing conditions in the upper atmosphere, where the jet stream is strongest and most capable of distant dispersal. Composites, a group of daisy-like flowers, produce seeds with parachute-like devices that are easily blown by the wind. The giant daisy

The seedlings of the red mangrove **(top)** may float for months, which allows them to disperse widely. The lightweight spores of lichen **(middle)** ensure that they are among the most widespread organisms on the planet. Over 140 species of ferns **(bottom)** have managed to colonize the Galapagos, of which a dozen are found nowhere else.

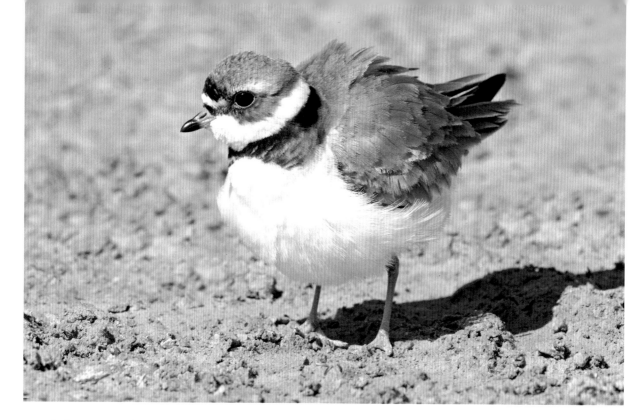

trees belonging to the genus *Scalesia* that grow in the moist uplands are a good example of a Galapagos composite.

What about plants that might have colonized the islands with the help of wildlife? Darwin, ever curious, devised experiments to look into that as well. In one case he collected three tablespoonfuls of sticky mud from a pond near his home. Eventually nearly 500 seedlings of multiple species sprouted from the muddy goo. The inquisitive naturalist reasoned that the muddy feet of birds might have accidentally carried the seeds of grasses and sedges to the distant Galapagos. Today, three birds with incriminating muddy feet that regularly migrate to the islands are Arctic-breeding semipalmated plovers; Wilson's phalaropes, which breed on the Canadian prairies; and yellow-crowned night herons, which stalk the mudflats of coastal Central America. Any one of them could be guilty of transporting seeds to the islands.

Many seeds are covered with barbs and hooks that can stick to a bird's plumage and then be carried to distant islands. Migrating birds can also unwittingly

The semipalmated plover **(top)** is one of the common annual migrants seen in the islands. The Scalesias **(above)** belong to the aster family, second only to the orchid family for total numbers of species worldwide. Colonizing seeds could easily be transported to the Galapagos on the muddy feet of a migrant yellow-crowned night heron **(opposite page)**.

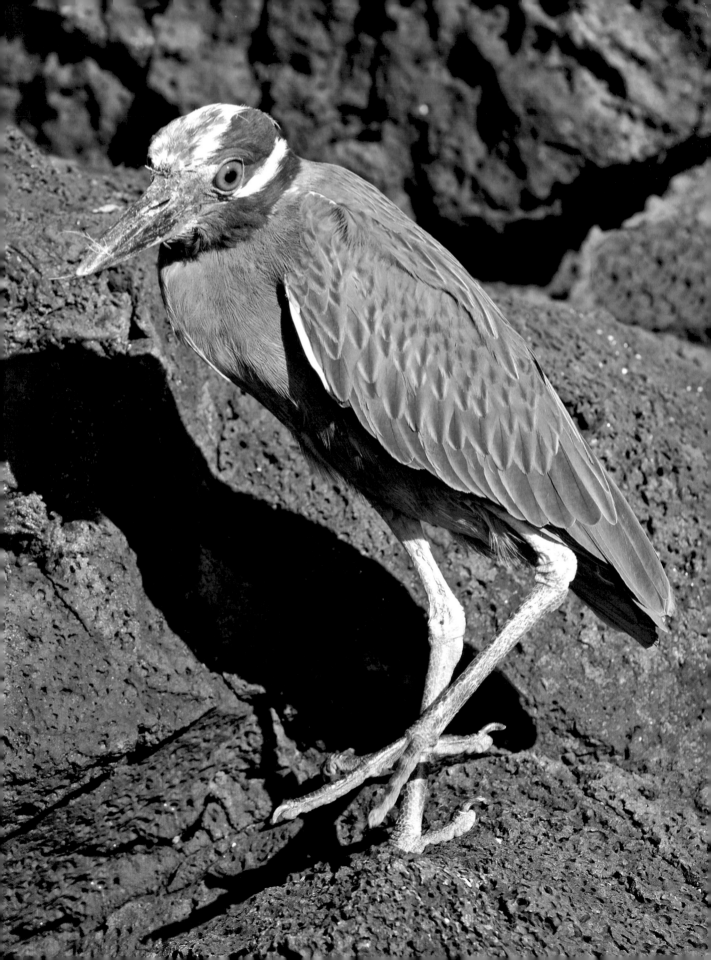

transport undigested seeds in their intestinal tracts, depositing them in distant lands in their droppings. When scientists analyzed how all the native plants had arrived in the Galapagos, they concluded that only a few of the original colonists arrived by sea, roughly a third were carried by the wind, and a little less than two-thirds were transported by wildlife. Of those carried by wildlife, around 65 percent were carried internally as undigested seeds, while the remainder arrived in roughly equal amounts either stuck to feathers or glued to muddy toes.

Accidental Castaways

The first animals to colonize the islands arrived as did the plants, by sea, by air or aboard an unsuspecting animal. Among those that came by sea, some swam, but most were carried on a raft of floating vegetation. During the rainy season, large rivers in Panama, Ecuador and Peru flood their banks, and rafts of matted vegetation more than 10 meters (33 ft) in diameter are frequently flushed into the ocean. These rafts may carry toppled trees and bushes, and they can easily transport plants, invertebrates, reptiles and even small mammals.

The average speed of the currents bathing the Galapagos Islands is about 4 kilometers per hour (2.4 mph). At that rate it might take a raft of vegetation less than two weeks to reach the islands. Most rafts would likely become waterlogged and sink in that time, but a fortunate few could survive. Some reptile specialists estimate that it would take only five successful raft trips over a million years to account for the diversity of today's Galapagos reptiles. Since the islands are many millions of years old, it is easy to see how this chance event could easily end in success.

So what were these unintentional animal pioneers

Water hyacinth and other tropical aquatic plants often form huge rafts that can be carried out to sea, transporting colonizing plants and animals to distant locations.

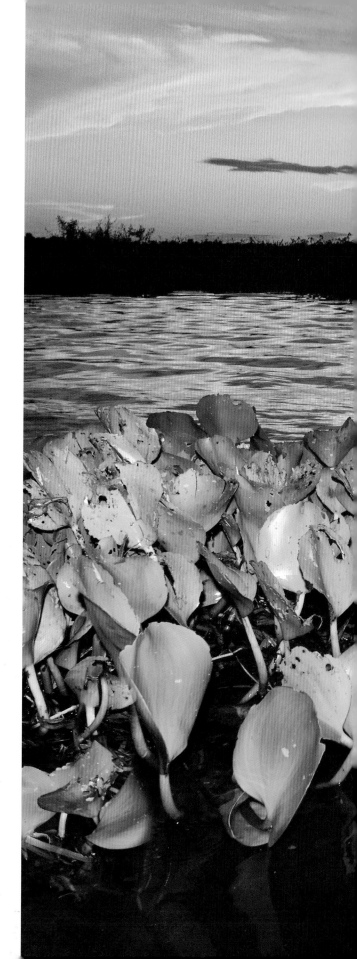

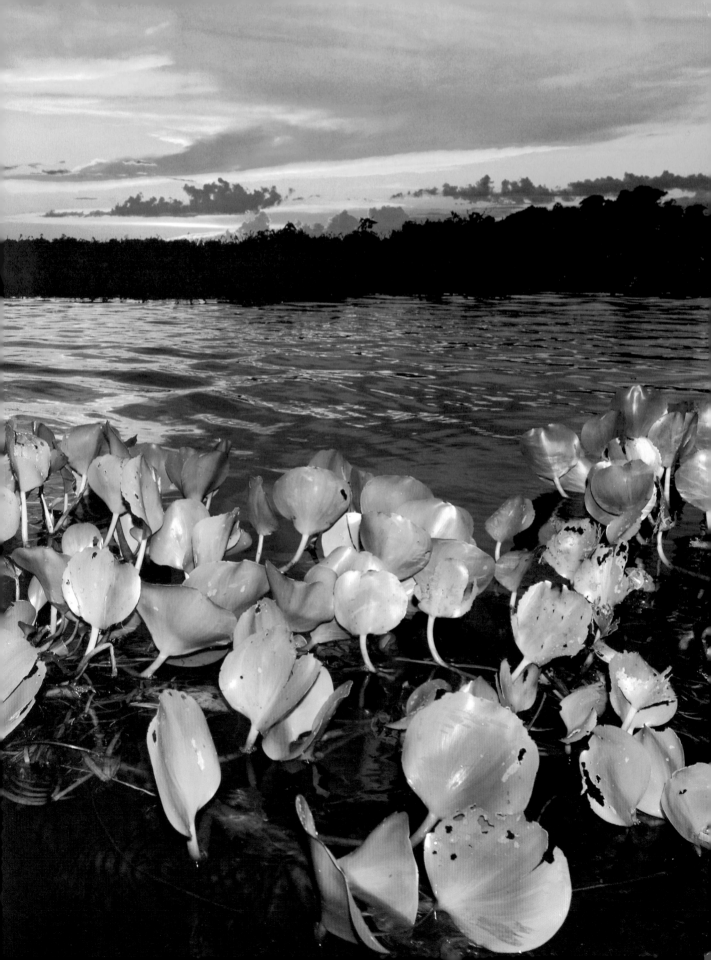

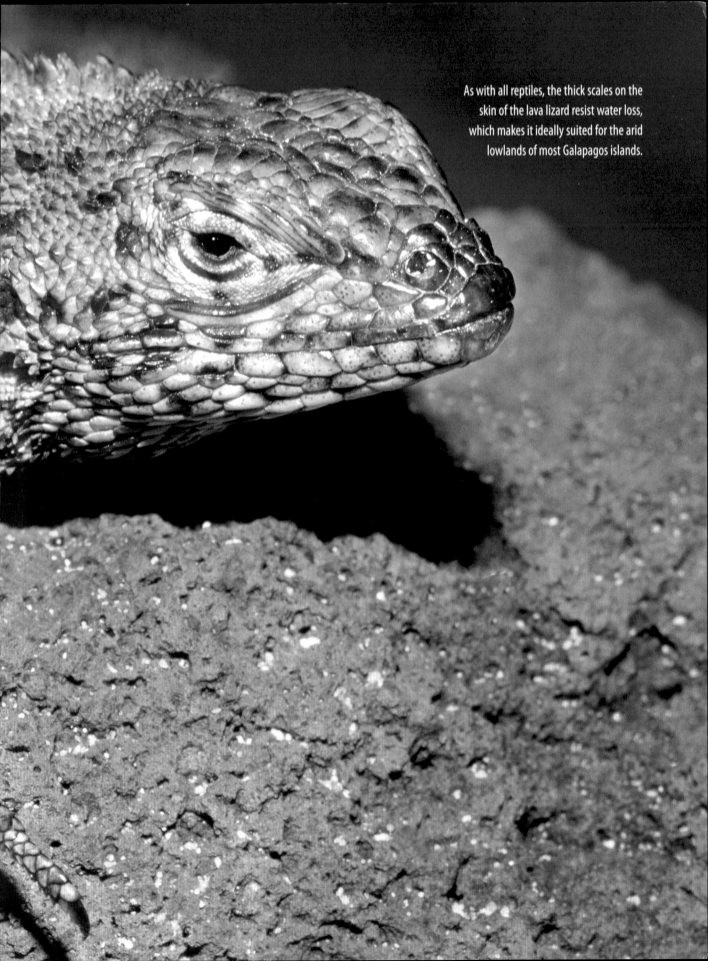

As with all reptiles, the thick scales on the skin of the lava lizard resist water loss, which makes it ideally suited for the arid lowlands of most Galapagos islands.

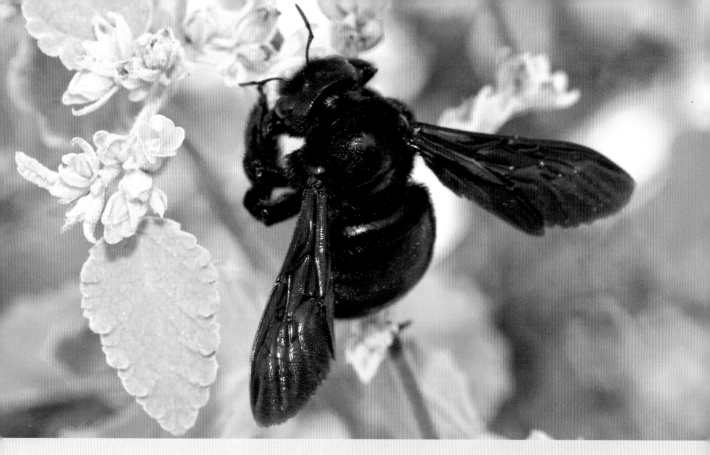

The carpenter bee **(above)** is the only bee in the Galapagos. Female bees are black and common whereas the males are brownish yellow and uncommon. Like all scorpions **(below)**, the two species in the Galapagos have venomous stingers at the tip of their tail, but neither is seriously dangerous to humans.

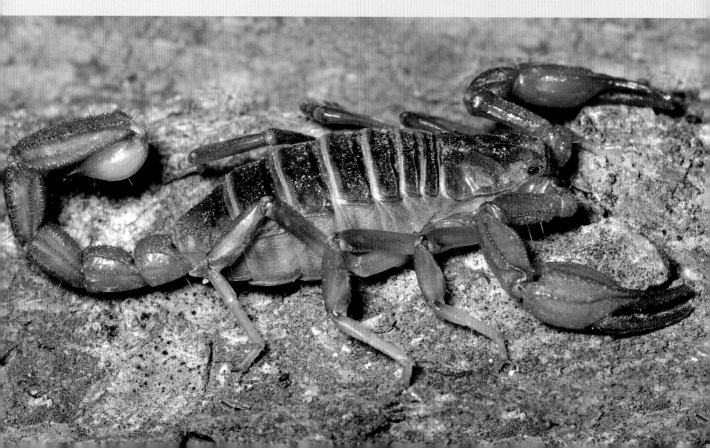

that were swept away on a floating mat of vegetation and made landfall on the distant shores of the Galapagos? Among them were invertebrates — the amazing creatures that I call "the spineless wonders" — such as ants and wood-boring beetles, which often live in hollow logs and would have been ideal candidates. So would scorpions that frequently hide under bark. And land snails can seal themselves inside their shells with a layer of mucus; this would have prevented them from drying out and kept them alive on a long ocean voyage. The queen carpenter bee, the islands' only species of bee, normally chews a tunnel in dead wood in which to lay her eggs, and such a refuge would have protected her and her young for many days at sea.

Hundreds of species of frogs, toads and salamanders live in the American tropics. Yet not one of these was successful in reaching the Galapagos. Amphibians' skin must remain constantly moist, so two weeks under the equatorial sun would have been lethal to them, and so would falling into the salty seawater.

Reptiles are much better stowaways than amphibians. Thirty-three species of tortoises, lizards and snakes now live in the Galapagos. Colonizing reptiles could endure a long ocean voyage aboard a floating raft because their skin is covered with scales that resist drying. Being cold-blooded, reptiles also require very little food and water to survive — just one-tenth as much as a hot-blooded mammal or bird of the same body weight. Centuries ago, giant tortoises destined to be eaten survived for many

At a wallow, a dominant giant tortoise may displace a subordinate.

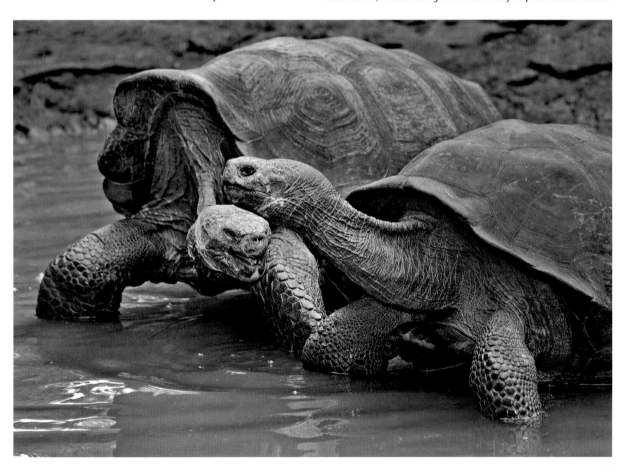

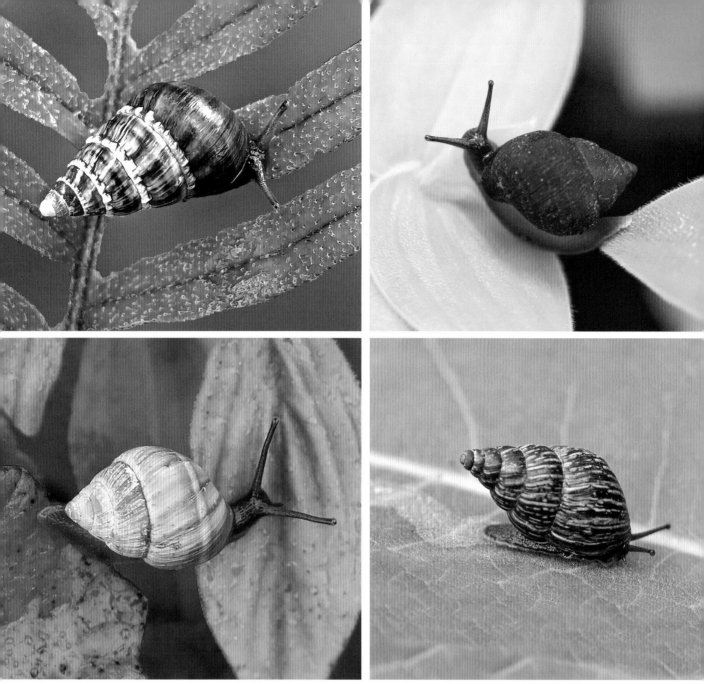

The Galapagos snails display a greater degree of adaptive radiation than any other creature to have colonized the islands.

Sneaky Snails

In one experiment, Charles Darwin dangled the amputated foot of a duck in an aquarium in which some freshwater snails had just hatched. Within hours, dozens of tiny snails, each no bigger than a grain of sand, were stuck to the duck's foot. Henry Nicholls writes: "No amount of waving [the foot] about could dislodge them, and a few survived for more than twelve hours out of water. In this time, Darwin figured, 'a duck or heron might fly at least six or seven hundred miles, and would be sure to alight on a pool or rivulet, if blown across sea to an oceanic island.'"

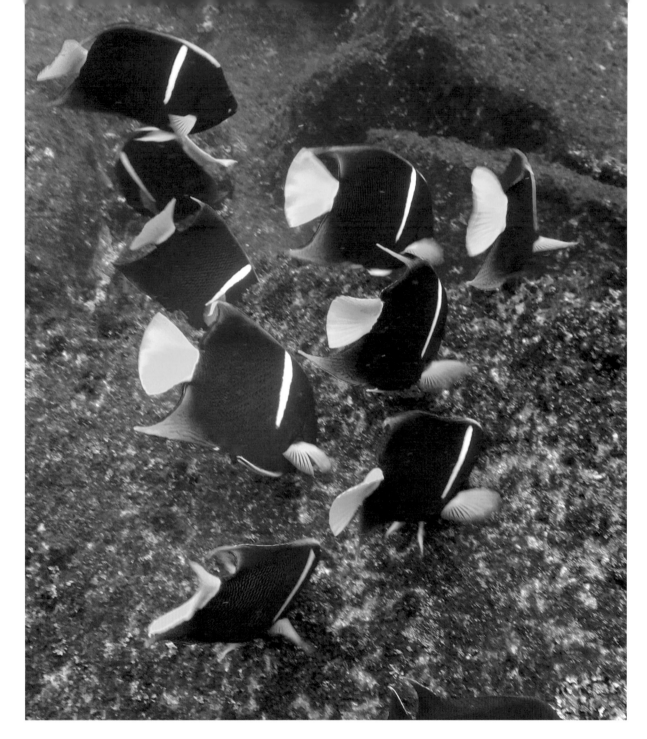

These king angelfish are grazing on algae covering a boulder resting on the seafloor.

months without food or water, stored as cargo in the holds of pirate ships.

Mammals, on the other hand, are poor at colonizing distant islands. Their high energy needs force them to eat and drink frequently; most perish within a few days without water. Miraculously, at least one pioneer rice rat made it to the islands after enduring a voyage of at least 1,000 kilometers (620 mi) — the longest colonizing trip ever made by a land mammal.

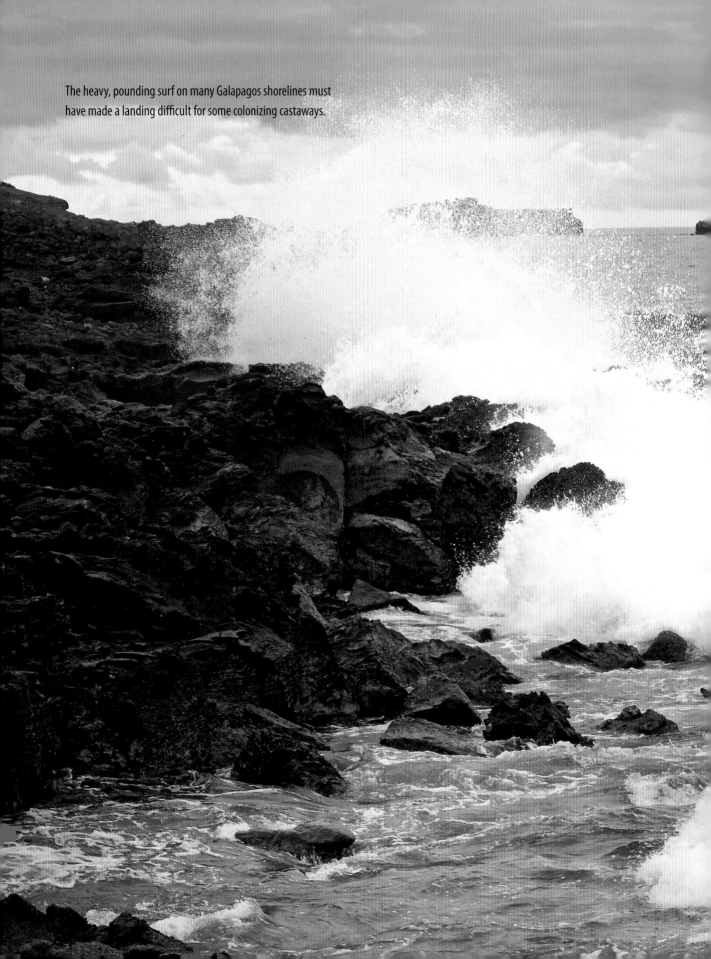

The heavy, pounding surf on many Galapagos shorelines must
have made a landing difficult for some colonizing castaways.

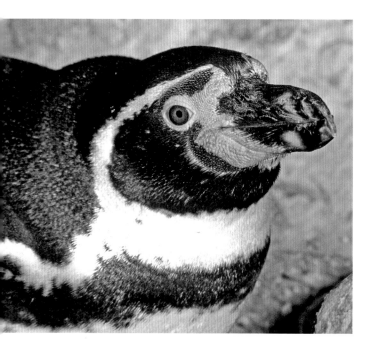

Sink or Swim

The second way that animals could reach the Galapagos by sea is by swimming there themselves. Fish are the most successful vertebrates in the world, totaling more than 32,000 species, of which over 60 percent live in the world's oceans. Over time, nearly 500 species of fish managed to swim to the Galapagos and colonize their surrounding waters, including 32 species of sharks (none of which is a threat to snorkelers).

I wouldn't be surprised if sea turtles were the first reptiles to reach the islands. Today, seven species of sea turtles range across all the tropical and temperate oceans of the world. Many make seasonal journeys that cover thousands of kilometers, so the isolation of the Galapagos Islands would not have been an obstacle to them.

The Humboldt penguin **(above)**, carried by favorable currents, is the likely ancestor of the endemic Galapagos penguin. South American fur seals **(right)** may swim hundreds of kilometers on foraging trips and, in former times, could easily have reached the Galapagos Islands in their wanderings.

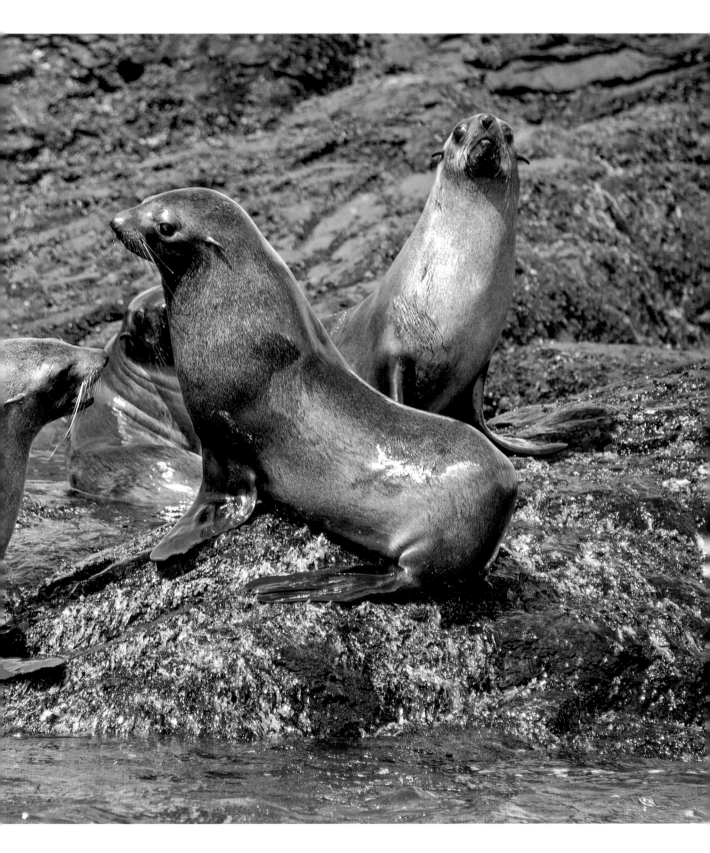

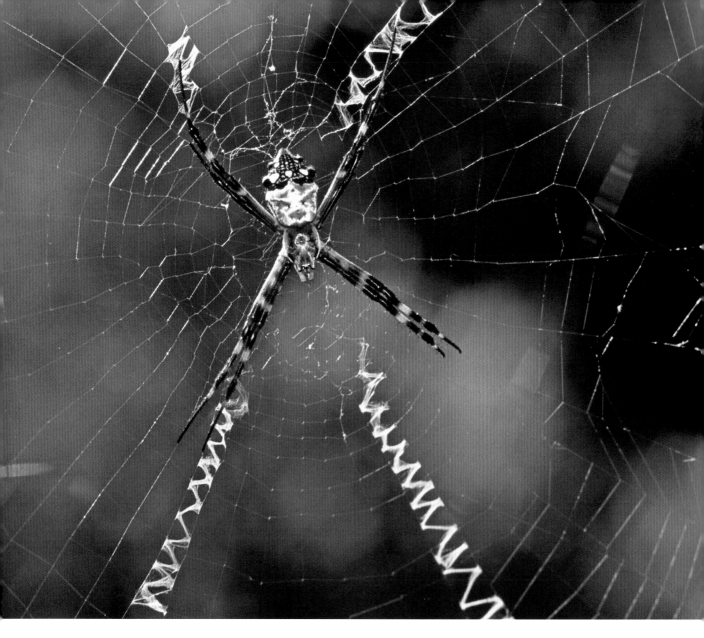

The silken designs on the web of the zig-zag spider are thought to be warnings, alerting birds to the web's location and preventing accidental damage.

More difficult to answer is the question of how a giant land tortoise weighing up to 250 kilograms (550 lb) made the journey. From genetic studies, scientists believe the first tortoise floated ashore on the Galapagos 2 to 3 million years ago. Was the pioneer a giant before it was washed into the Pacific and drifted out to sea, or was it a smaller tortoise that became a giant after it arrived on the islands?

Most authorities agree that only a large tortoise could endure a lengthy swim at sea. Tortoises are not at all good swimmers and really just bob along. But a large tortoise can store more fat than a small one can, it can hold its head higher above the waves, and it is stronger and better equipped to climb over rough lava shores once it lands.

Only one bird, the Galapagos penguin, swam all the way to the islands. Its closest relative, the Humboldt penguin, lives on the southwestern coast of South America. It's likely that the northward-flowing Humboldt Current guided the first penguin

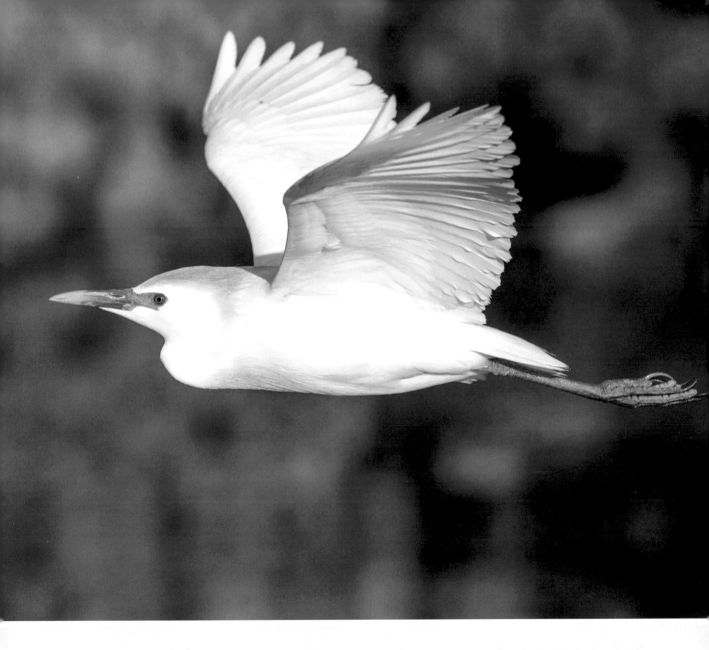

The Wandering Cattle Egret

The most recent bird to naturally colonize the Galapagos is the cattle egret. It's a story worth telling. The egret is native to Africa and the humid Asian tropics. It usually associates with grazing animals, feeding on insects that are flushed when the animals disturb the soil with their hooves. Beginning in the late 1800s, the egret began to disperse widely from its native range, for reasons that no one understands. By 1877 the egret had crossed the Atlantic and was sighted in northern South America, probably assisted in the 4,300-kilometer (2,670 mi) journey by the winds of a tropical storm. Within 60 years it had moved through Central America and Mexico and was living in Florida. In the decades that followed, it flew north into Canada and on to Alaska. It also dispersed south to Tierra del Fuego, at the southern tip of South America. This colonizing egret eventually made the crossing to the Galapagos Islands and was seen for the first time in 1964, but it wasn't observed breeding until 1986. The cattle egret is now a common sight in the agricultural areas of the archipelago.

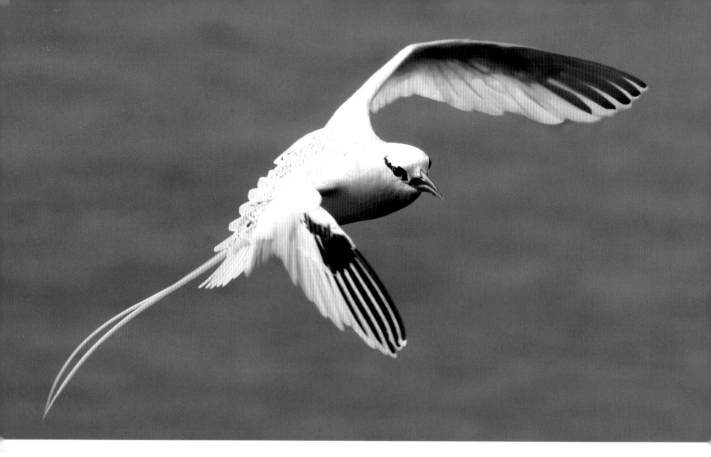

The red-billed tropicbird **(above)**, which feeds on fish and squid, catches its prey by plunge diving, usually far out at sea. Storm petrels **(below)**, sometimes called sea swallows, are seabirds that flutter and hop across the ocean surface feeding on tiny invertebrates.

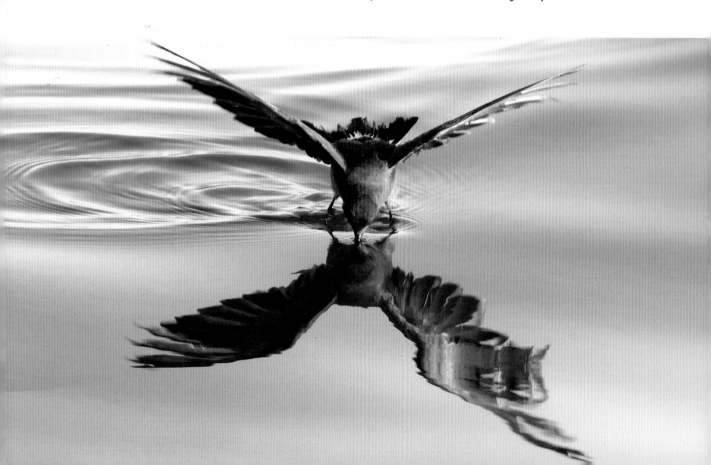

colonists to the shores of the Galapagos Islands.

Marine mammals probably made it to the islands long before the land was settled. Today, 24 species of whales and dolphins have been seen in the waters surrounding the archipelago. For their ancestors it would have been a relatively easy task to journey to the Galapagos, with no extra help needed. Sea lions and fur seals, the fin-footed marine mammals, also made it to the Galapagos after a lengthy swim.

Today one species of sea lion, the Galapagos sea lion, lives in the islands. Its closest relative is the California sea lion. In earlier times a California sea lion may have been guided to the archipelago by the southward-flowing Panama Current. In a similar way, an ancestral South American fur seal was likely guided to the islands by the northward-flowing Humboldt Current. After years of isolation it evolved into the Galapagos fur seal, the smallest fin-footed marine mammal in the world.

Up, Up and Away

Colonizers such as butterflies, hawk moths and dragonflies presumably reached the Galapagos in part by using their own powers of flight, although they were likely assisted by the strong winds that always accompany tropical storms. Spiders as well were probably hurled toward the islands with the help of hurricane winds. Newly hatched spiders, called spiderlings, typically colonize distant lands by spinning out a strand of silk and waiting for a wind to "balloon" them away. Such spiderlings have been recovered in the rigging of ships hundreds of kilometers from shore.

Naturally, no reptile or fish colonized the Galapagos by air, unless you believe Hollywood's disaster comedy *Sharknado*, in which a freak tornado carries man-eating sharks into Los Angeles. The most obvious colonists arriving by air were birds. Dozens of bird species pass through the Galapagos every year, some following their lengthy oceanic

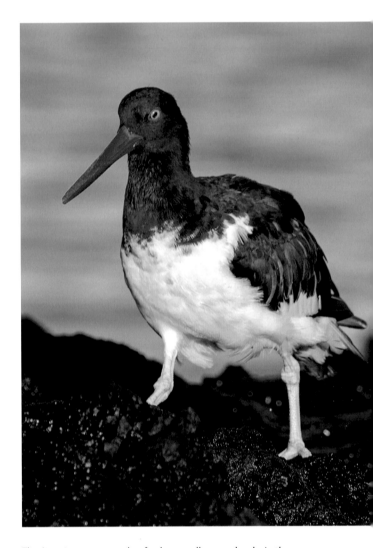

The American oystercatcher feeds on molluscs and crabs in the intertidal zone of the shoreline.

migration path and others blown off course by storms. It's no surprise that a number of these birds found the islands attractive as a breeding ground and stayed on to become colonists.

Seabirds naturally hold a prominent place in the Galapagos Islands, since the archipelago is surrounded by the vastness of the Pacific Ocean, the largest ocean on the planet. Today, 19 species of seabirds breed in the islands, including storm petrels, boobies, tropicbirds, frigatebirds, pelicans and terns. Six of these seabirds — the Galapagos penguin,

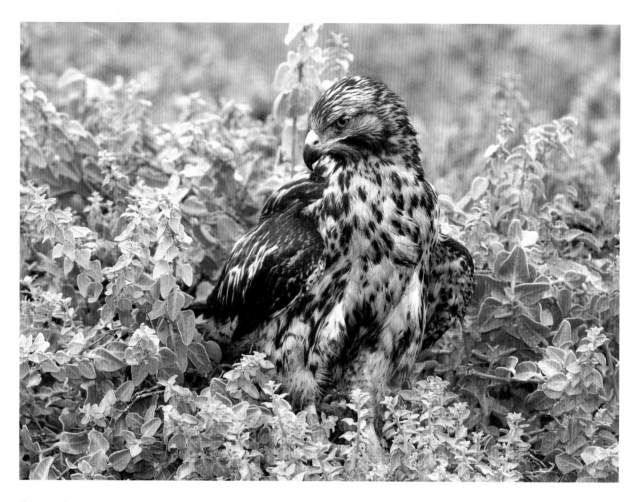

The juvenile Galapagos hawk **(above)** and the juvenile Swainson's hawk **(opposite page)** of North America look surprisingly similar and the latter species is the likely ancestor of the Galapagos species.

flightless cormorant, waved albatross, Galapagos petrel, lava gull and swallow-tailed gull — are found nowhere else in the world. Another nine breeding species, called coastal birds, forage along the shorelines. These include herons, flamingoes and oystercatchers. The greatest number of Galapagos bird species (32 in total) are not associated with the ocean at all; instead they breed and forage on land. Among these are hawks, owls, doves, flycatchers, mockingbirds and the famous finches that bear Charles Darwin's name. I will discuss many of these birds in detail in a later chapter.

The only mammals that can fly also established themselves in the islands. Two species of bats — the Galapagos bat and the hoary bat — now live in the Galapagos. They are most commonly seen at night, flitting about the street lights in the three towns on the islands.

The Greatest of Ideas

After the first immigrants made it to the Galapagos Islands, their struggles were just beginning. Many likely died from thirst, starvation or both. There may have been hundreds of unsuccessful colonizers before the fortunate few survived and reproduced. Evolution, through the process of natural selection,

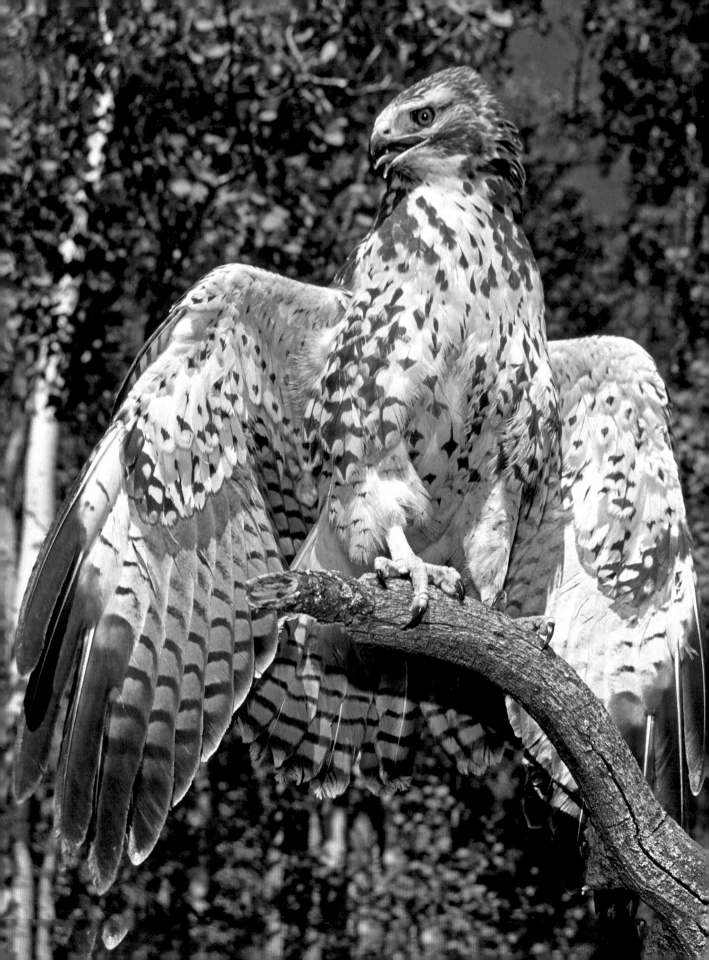

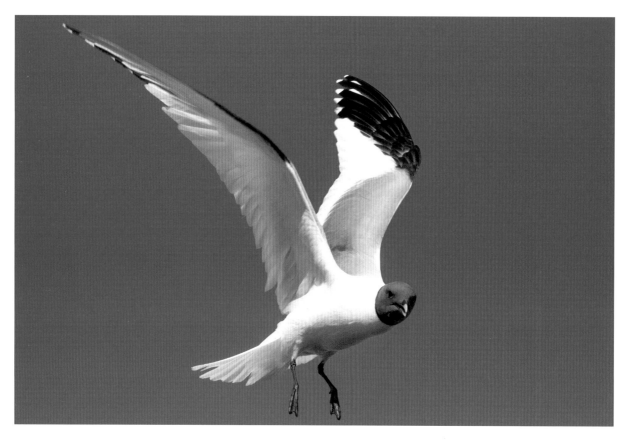

The Arctic-breeding Sabine's gull **(above)** migrates in the winter to the western coast of South America. It's easy to imagine how a tropical storm might blow a group of migrants far enough offshore for them to colonize the Galapagos, eventually evolving to become a new species, the swallow-tailed gull **(opposite page)**.

was the major instrument that determined which colonists would succeed and survive and which would fail and perish.

Natural selection was the brilliant brainchild of Charles Darwin, who proposed the concept in his monumental book *On the Origin of Species by Means of Natural Selection, or the Preservation of Favoured Races in the Struggle for Life*, published in 1859. Many think it is one of the most important ideas of all time, genius in its simplicity. Natural selection has no hidden purpose or goals; it is simply a filtering mechanism. Understanding it begins with the simple observation that variety exists within every population of organisms, whether they be

seabirds, lizards, tortoises or rice rats. If you want to confirm this obvious fact, look at our own species: humans display a bewildering variety of skin colors, body shapes and facial features.

When environments change or when a species is confronted with a new environment, as would likely happen to an island colonist, those varieties that are best suited to the new conditions produce more young than those less suited. Eventually the ill-suited varieties disappear and the well-suited ones prevail and dominate. The winners pass on their successful traits to their offspring and the species multiplies. If a successful colonist is different enough from its parent population, it may gradually evolve

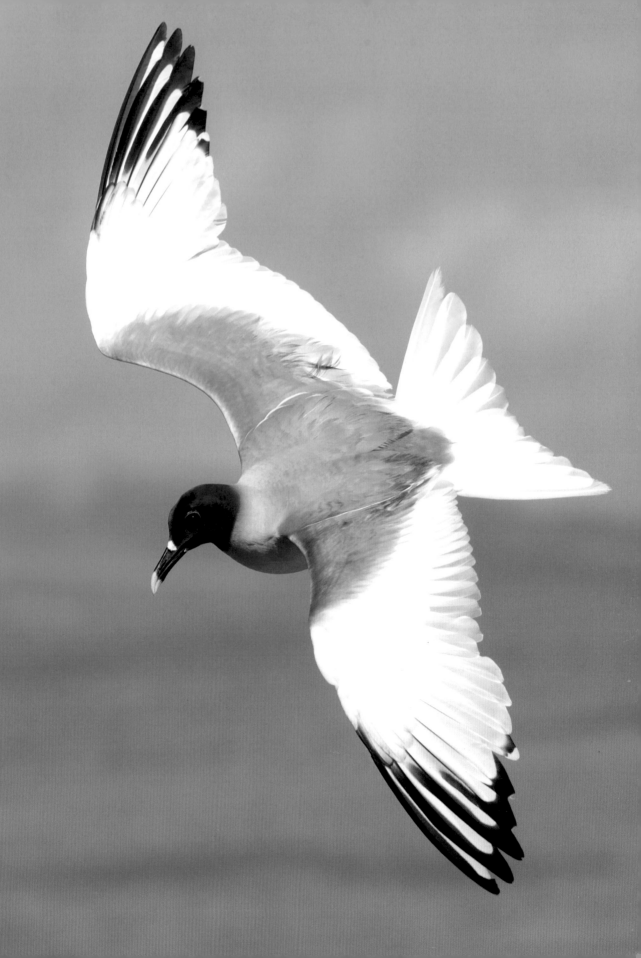

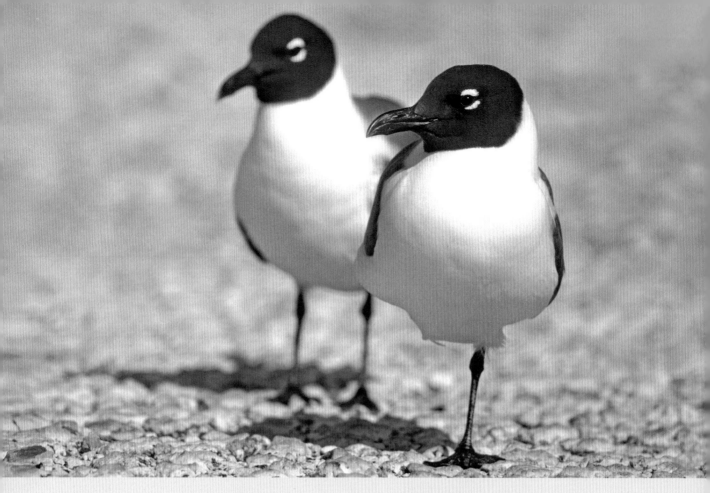

The laughing gull **(above)** is the likely ancestor of the endemic lava gull **(below)** of the Galapagos, its plumage darkening to more closely match the black lava of its shoreline habitat.

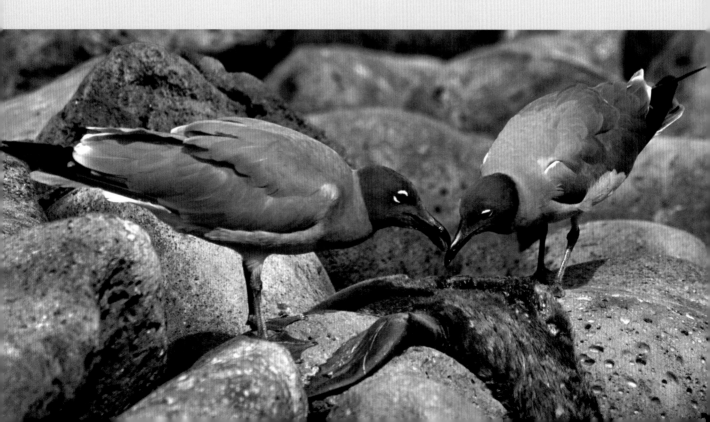

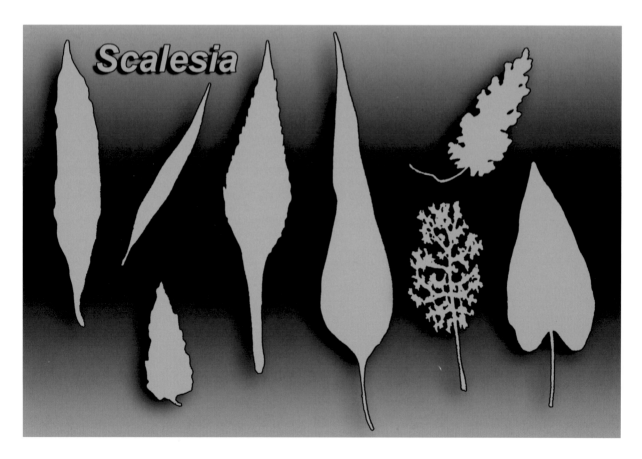

From a single daisy-like ancestor, the endemic Scalesias of the Galapagos radiated into 15 separate species displaying an array of leaf designs.

into a new and separate species. Humans are just another product of evolution, each of us an evolved thread in the fabric of life. Darwin revealed to us who we really are and where we came from.

On a newly colonized island with a variety of habitats, a single founding species can sometimes split and become multiple species, each with its own distinctive lifestyle and subtle differences in appearance. This process, which has the fancy technical name *adaptive radiation,* happened many times in the history of the Galapagos Islands. For example, one pioneering daisy-like *Scalesia* species eventually split and became 15 separate species, many with vastly different leaf shapes and habitat preferences. In another instance, a single tortoise settler ultimately radiated into 16 different giant tortoise species throughout the archipelago, many alone on their own volcanic cone. The mockingbirds are yet another example, in which one species split into four, and Darwin's famous finches radiated from one colonizer into 14 separate species.

The most dramatic example of adaptive radiation in the Galapagos belongs to a humble little land snail that has no common name, only the tongue-twisting scientific name *Naesiotus.* This small variable snail eventually split into more than 60 species. And so it went: over millions of years and from multiple colonists, the distinctive flora and fauna of the islands were shaped through the wondrous simplicity of natural selection and then expanded by adaptive radiation.

Invasion of the Naked Apes

Primatologists who study monkeys and apes view humans as just another ape, albeit one with scarcely any hair. Humans are genetically so close to chimpanzees that we

might still be able to breed with them (a disturbing thought, but nonetheless true). The arrival of humans on the Galapagos was a relatively recent event.

The British naturalist Charles Darwin was certainly the most famous human ever to visit the islands. The story of how he came to be there illustrates how a twist of fate can lead to unexpected rewards. Darwin's father and grandfather were highly successful physicians, and in keeping with family tradition, the young Charles enrolled in medical school in Scotland. Much to his father's disappointment he eventually dropped out and entered a liberal arts program at Cambridge University, with a view to becoming a modest country pastor so he would have time to indulge in

his real passion, a love of natural history.

In the early 1800s, Britain wanted to accurately survey the coast of South America to provide British merchant ships with better maps of the area. Unfortunately, Pringle Stokes, the captain of the first voyage sent to do the mapping, became severely depressed and shot himself in the head while sailing the stormy seas of Tierra del Fuego. A year later, his replacement, Robert Fitzroy, worried that the same thing might happen to him, so he requested the company of a gentleman companion with whom he could discuss intellectual subjects and keep his mind stimulated. Darwin's uncle recommended him for the position, but his father thought it was a waste of money.

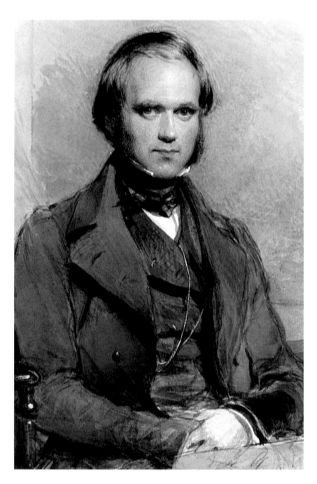

In the initial interview, Fitzroy was skeptical about Darwin, and for an unusual reason: the shape of his nose. Many people at the time thought that a person's facial features revealed much about their character. Darwin's nose, which was large and rounded, did not indicate to Fitzroy that he had sufficient resolve for such a long and arduous voyage at sea. Years later Darwin wrote that once Fitzroy got to know him, he was "well-satisfied that my nose had spoken falsely."

Aboard HMS *Beagle*, Darwin was both a conversational partner for the captain and a volunteer naturalist, since the British naval office had no budget to hire a professional scientist. The *Beagle*'s voyage was meant to last just two years but ultimately went on for nearly five. By the time the ship reached the Galapagos, 26-year-old Darwin had been at sea for three and a half years; he was

An 1840 portrait of Charles Darwin **(left)**, painted four years after he returned home from his landmark voyage aboard the Beagle. Darwin's rhea **(below)**, also known as the lesser rhea, was collected by the famous naturalist during his travels along the southern coast of Argentina.

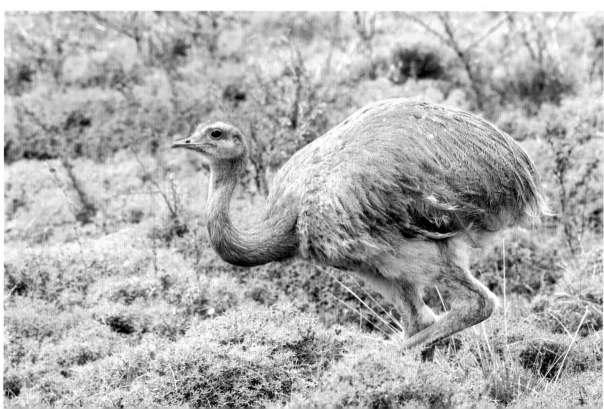

Mariners know the seas around Tierra del Fuego at the southern tip of South America are notoriously stormy and dangerous.

homesick and not looking forward to their survey of the islands. They explored the archipelago from September 17 to October 20, 1835. In those five weeks Darwin collected specimens of all kinds before they sailed home across the Pacific.

A common myth is that Darwin became a believer in evolution during his stay in the islands. In fact it was not until he was back home in England and began cataloging the many specimens he had collected in the Galapagos that he had his first ideas about evolution. After his years aboard the *Beagle*, Darwin never left England again. He spent the next two decades of his life building the scientific proof he needed to support his famous theory.

Lost at Sea

In 1535, three hundred years before Darwin landed in the Galapagos, the islands were first discovered by humans. In those days representatives of the

Catholic Church sometimes worked as ambassadors for reigning monarchs, so the king of Spain asked the bishop of Panama, Fray Tomas de Berlanga, to sail to Peru. His mission was to report on the greedy, bloodthirsty conquistadors who had conquered the Incas; they were now fighting each other over the gold and other riches they had acquired when they defeated the Incan empire. As he was en route from Panama to Peru, the winds died, and Berlanga's ship was carried along by a strong current flowing westerly into the unknown Pacific. After many days without food and water, the crew sighted land — the Galapagos Islands — and thought they were saved.

The sailors found animals to eat but water was scarce, so the desperately thirsty men were forced to chew cactus pads for their moisture. In his report to the king, Tomas described "such big tortoises that each could carry a man on top of itself … many iguanas that are like serpents … and many birds so silly that they do not know how to flee." Eventually the ship found fresh water and favorable winds that carried them back to South America.

Pirates, Predators and Prisoners

For three centuries following the discovery of the islands, their visitors were a sad string of villains, wildlife butchers and criminals. In the 16th and 17th centuries, British, French and Dutch pirates waging war against Spain used the Galapagos as a hideout from which to attack Spanish galleons sailing from South America, carrying cargos of gold. The pirates collected water, wood and tortoises from the islands.

After the buccaneers came the whalers. Between 1780 and the 1860s, the waters around the Galapagos were a favorite hunting ground for British and American whalers. Sperm whales, the largest of the toothed whales, were hunted for the valuable oil in their heads. This oil, called spermaceti, was used to make expensive candles and fine lubricants.

The main reason Ecuador claimed the Galapagos Archipelago in 1832 was the presence of a lowly lichen called dyer's moss **(above)**, which when boiled in livestock urine produced the deep purple dye favored by popes and kings. The desperately thirsty sailors on Berlanga's ship resorted to chewing on cactus pads **(below)** to quench their thirst.

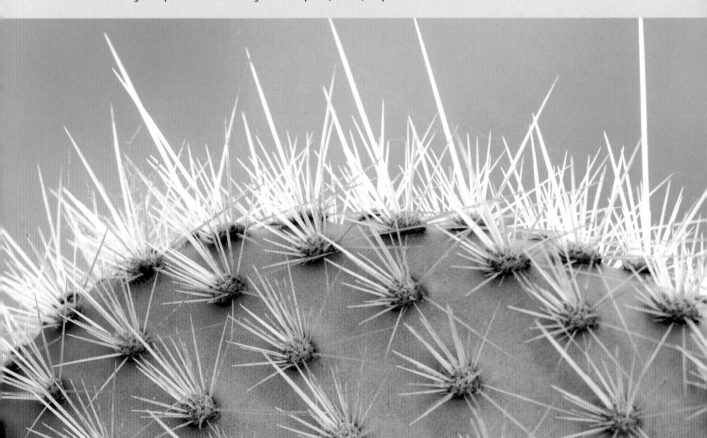

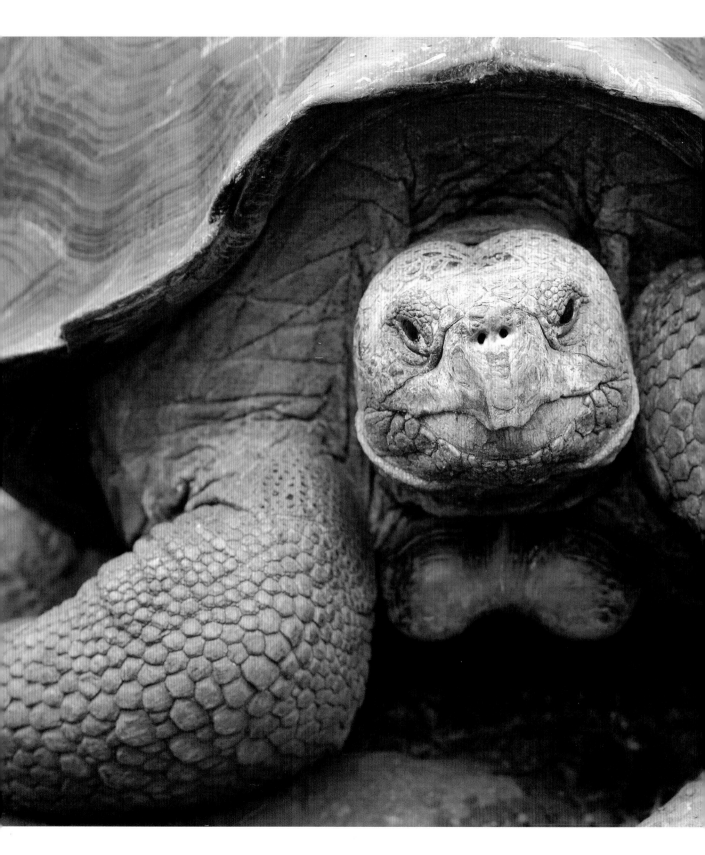

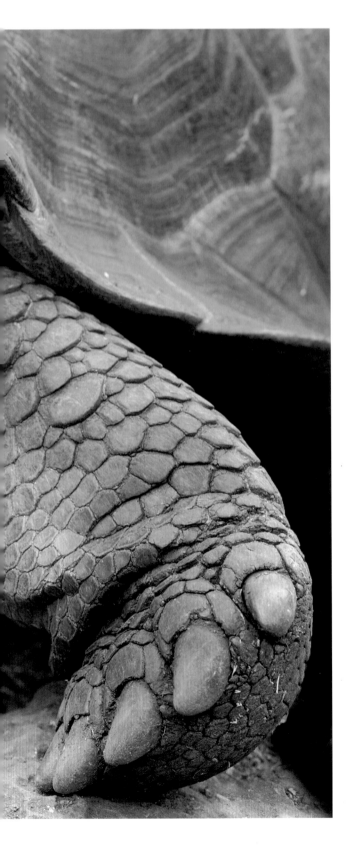

It was also used in oil lamps, as it burned more brightly and cleanly than any other oil available and gave off no foul odors. Hunting sperm whales was a profitable business: a large whale might yield as much as 1,300 liters (500 gal) of oil. Eventually, in the late 1800s, cheaper kerosene replaced whale oil.

The American naval captain David Porter commented on the whalers' treatment of the islands' giant tortoises: "Vessels on whaling voyages among these islands generally take on board from two to three hundred of these animals, and stow them in the hold, where, strange as it may appear, they have been known to live for a year, without food or water, and when killed at the expiration of that time, found greatly improved in fatness and flavor." By some estimates, more than 200,000 tortoises were removed from the islands, killed and eaten by the whalers. One author observed that the tortoises were just too big to hide, too slow to run, too timid to fight and too tasty to be ignored.

In 1807 Patrick Watkins became the first person to settle permanently on the islands. Watkins was an Irish castaway who lived on Floreana Island, growing vegetables that he bartered for rum with the passing whalers. One whaling captain described him as "the most dreadful that can be imagined: ragged clothes, scarce sufficient to cover his nakedness, and covered with vermin; his red hair and beard matted, his skin much burnt from constant exposure to the sun, and so wild and savage in his manner and appearance that he struck everyone with horror." After two years marooned on Floreana, Watkins stole a whaling ship, kidnapped five sailors as slaves and sailed with them to Guayaquil, on the Ecuadorian coast. By the time he arrived at the mainland all five prisoners had mysteriously disappeared. Were they cannibalized

Giant tortoise populations were decimated in the islands, first by pirates, then by whalers, both of whom used the reptiles as a transportable food source.

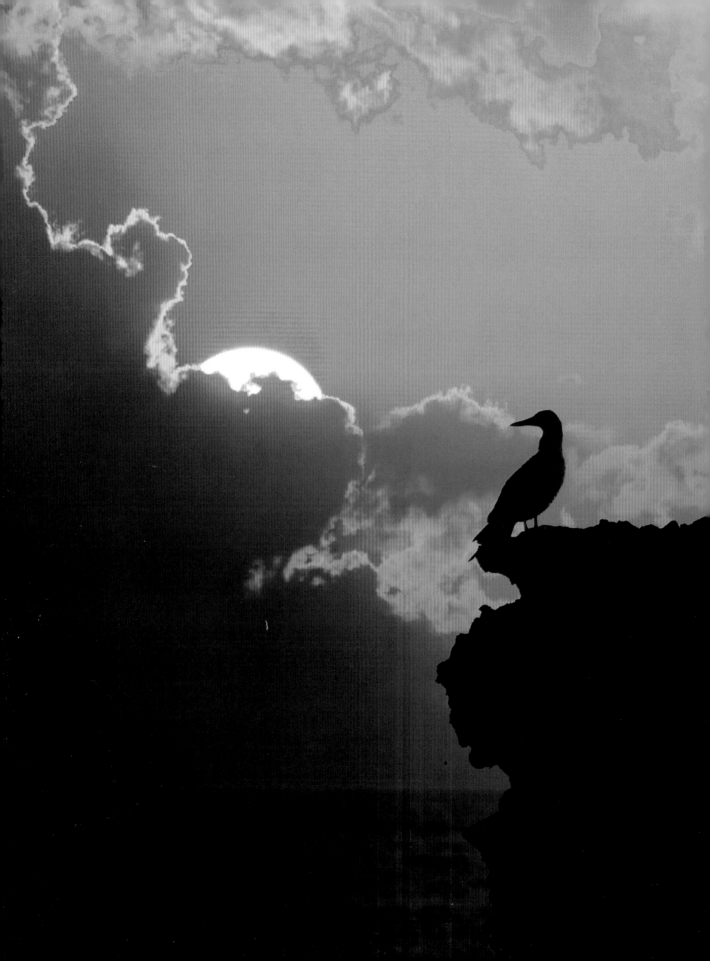

Pirates and whalers thought the blue-footed booby was stupid
or foolish because it was so easy to approach and capture

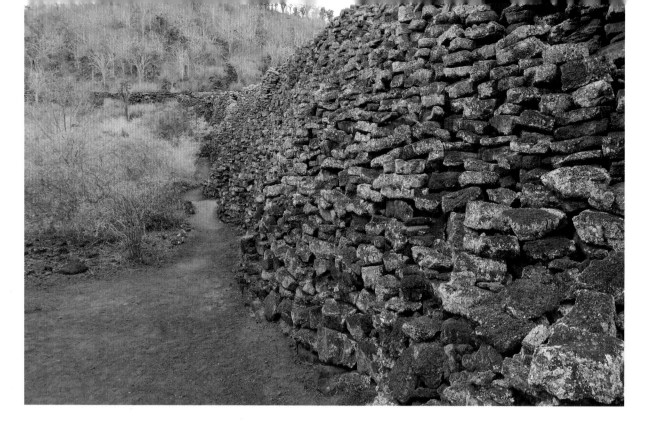

The "wall of tears" in southern Isabela Island was built by prisoners in 1946 to keep them busy. The harshly punished convicts had a saying: "Here, the strong cry and the weak die."

or simply cast overboard? The answer remains a mystery.

In 1832 Ecuador finally claimed ownership of the Galapagos Islands, which had originally belonged to Spain. The main reason they wanted the archipelago was to harvest a lowly lichen called dyer's moss. When the lichen was boiled in an acid solution such as livestock urine, it produced a deep purple dye. Purple was the color used for garments worn by popes, kings and queens, so such dyes were highly valued. Prices plummeted in the 1870s, when European chemists developed much cheaper synthetic dyes.

Soon after Ecuador laid claim to the Galapagos, it began to use these remote islands as a penal colony — a place to get rid of convicts, political prisoners and other unwanted people. Penal colonies were established on Floreana, San Cristobal and Isabela, where inmates were beaten, tortured and forced to endure hard labor. The prison on San Cristobal was called El Progresso, but despite its uplifting name it was a hellhole, ruled by a cruel tyrant who was eventually murdered with a machete by one of the prisoners. The last prison was finally closed in 1959.

A Trickle Becomes a Flood

In the aftermath of the First World War, the rich and famous became obsessed with yachting and the Galapagos Islands was a popular destination. Thus tourism began, aboard luxury boats that offered elegant dining and chilled champagne. These pleasure voyages were often associated with large universities and museums, with the passengers pretending to do science and earning a tax deduction in return.

As the wealthy were getting sunburned in the islands, the US government was trying to buy the Galapagos from Ecuador, as a base to strengthen its defense of the Panama Canal. In those same years a group of wealthy American anglers also

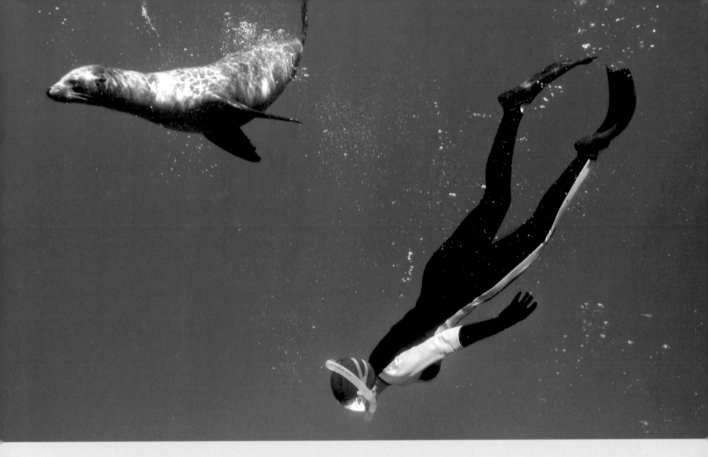

Galapagos sea lions are playful and commonly approach snorkelers, in this case the author's wife.

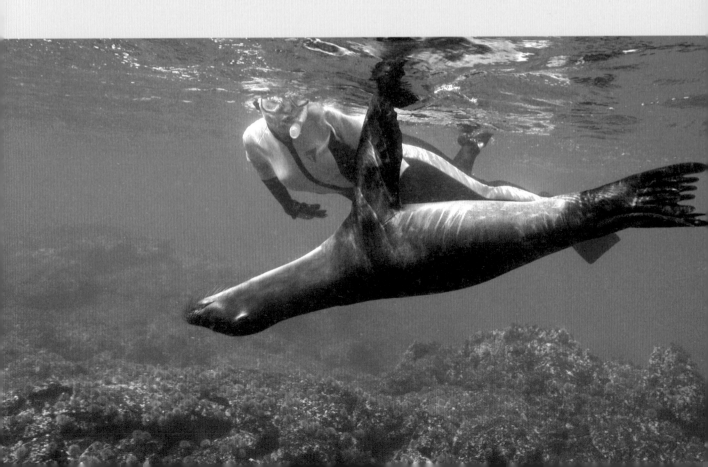

tried to purchase the archipelago to use as a private wildlife and fishing preserve. Thankfully — for both the wildlife and humanity — the money-starved Ecuadorian government resisted both offers. Nonetheless, when the Japanese bombed Hawaii's Pearl Harbor on December 7, 1941, the US military moved its war machine into the Galapagos. With Ecuador's permission, the Americans built a mile-long runway to ensure protection of the vulnerable Panama Canal.

When the American military arrived in 1942, just 800 hardy souls lived in the islands. Once the airfield was built, large commercial aircraft could land. The floodgates to the isolated archipelago began to crack open. The first tourist ship to visit the enchanted isles was the legendary *Lindblad Explorer* with its 75 nature-loving passengers. In 1969, a year later, more than a thousand tourists came to marvel at the amazing wildlife, and a decade later the total had swelled to 12,000. When I visited in 1992, more than 40,000 other tourists had the same idea. When I returned most recently, in 2015, over 220,000 tourists flooded the archipelago. Ecotourism can be a double-edged sword. Public awareness and appreciation can lead to stronger environmental protection, but uncontrolled tourism can lead to unsustainable growth and cook the fairytale goose that laid the golden egg. I will discuss these and other threats to the islands in a later chapter.

Galapagos regulations require that visitors not disturb wildlife by approaching them too closely. These curious young sea-lion pups are clearly ignoring the rules.

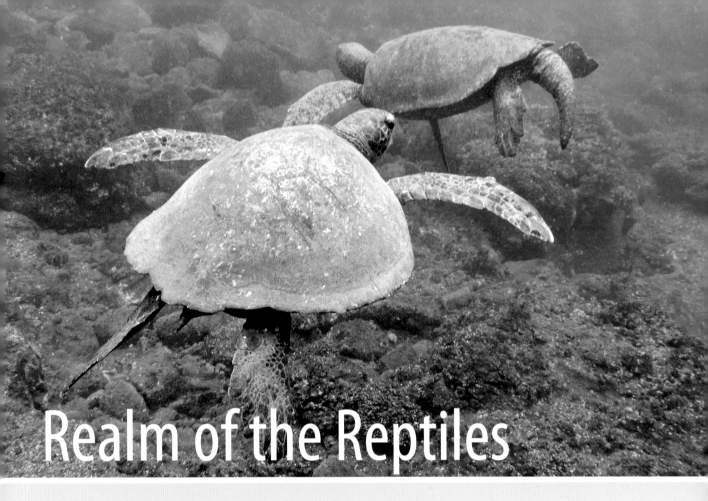

Realm of the Reptiles

On the Galapagos, reptiles are the dominant four-legged animals, earning the islands a reputation as a refuge for antediluvian beasts. A more scientific,

less biblical view is that the Galapagos is a unique global sanctuary where a diversity of cold-blooded creatures, perfected for survival by natural selection, can be enjoyed at arm's length.

Galapagos reptiles come in three flavors: chelonians, which includes sea turtles and land tortoises; lizards, which includes land and marine iguanas, lava lizards and geckos; and snakes, including both sea snakes and land snakes.

Sea turtles, being the great ocean wanderers that they are, were probably the first reptiles to colonize the Galapagos. Four species swim in the waters surrounding the archipelago, but three of these — the olive ridley, the leatherback and the hawksbill — are spotted only occasionally. The last of the

four, the Pacific green sea turtle, is the only species to nest in the Galapagos, and the chances of seeing one are very good. Many island tourists have never snorkeled before coming to the Galapagos, and the delight they experience when they see their first sea turtle underwater makes many of them giddy.

The green sea turtle, weighing up to 120 kilograms (265 lb), is the second largest of the seven species of sea turtles in the world; only the 900-kilogram (2,000 lb) leatherback is larger. Among the seven species it is the only vegetarian, feeding mainly on marine algae, sea grasses and mangrove shoots.

All the sea turtles share certain general features. All are long-lived — the green sea turtle to 80 years

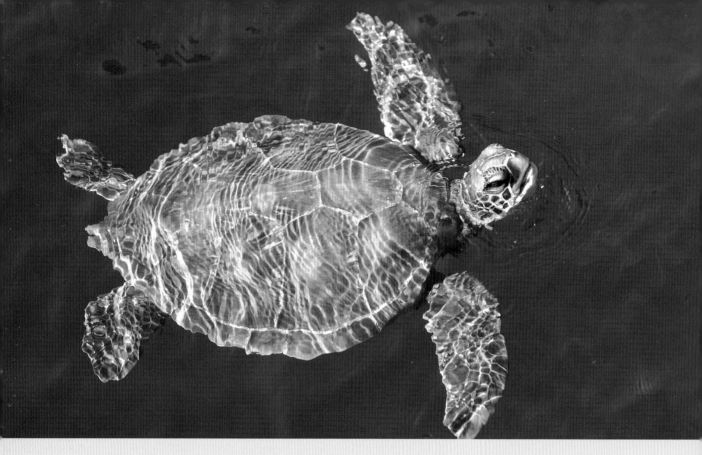

The shell of the hawksbill sea turtle **(above)** is the primary source of tortoiseshell used for jewelry and decoration since Egyptian times. The leatherback sea turtle **(below)**, which feeds mainly on jellyfish, is the largest sea turtle in the world, weighing up to 900 kilograms (2,000 lb) and measuring over 2.5 meters (8 ft) from its nose to its tail.

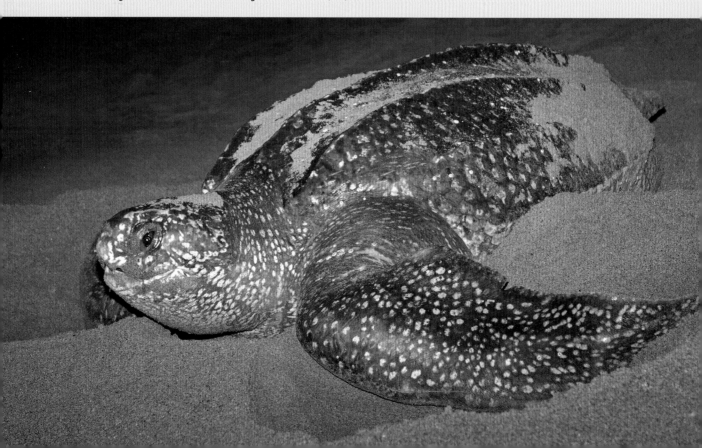

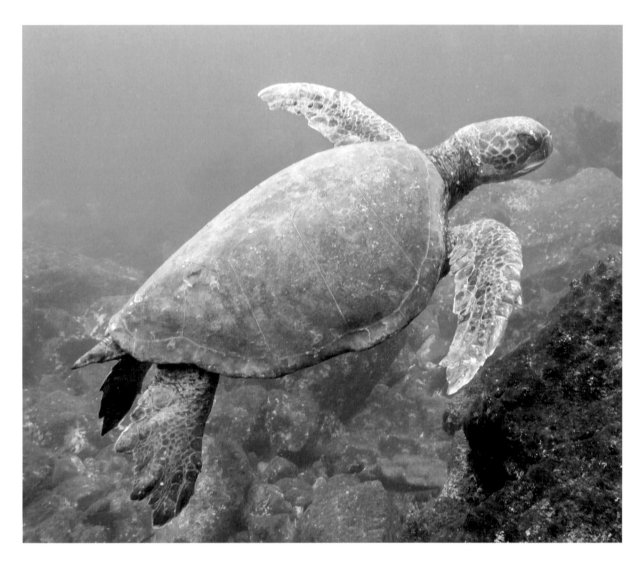

or more — and they mature late in life. The Pacific green may begin to breed when it is 8 to 13 years old but sometimes delays that until it is 25 to 30.

All sea turtles dig a nest on an ocean beach, usually where they themselves hatched, where they lay a clutch of eggs. The female green sea turtle typically lays two to three clutches of leathery-shelled eggs, each clutch containing up to 80 eggs. Laying eggs takes lots of energy and females need time to recover, so they don't nest every year. The green sea turtles in the Galapagos lay just once every three to four years, with the peak nesting season occurring during the hot/wet season, from December to June.

The short tail on this green sea turtle identifies it as a female. Males have a conspicuously long tail, as seen in the photo in the opening of this chapter.

One aspect of sea turtle life that I find especially fascinating is how the sex of a hatchling is determined. Sea turtles have no sex chromosomes (unlike amphibians, birds and mammals); the temperature of the eggs, usually during the middle third of incubation, controls the sex of the hatchlings. In Pacific green sea turtles, incubation temperatures of 28°C (82°F) or less yield male baby turtles and temperatures over 30°C (86°F) yield

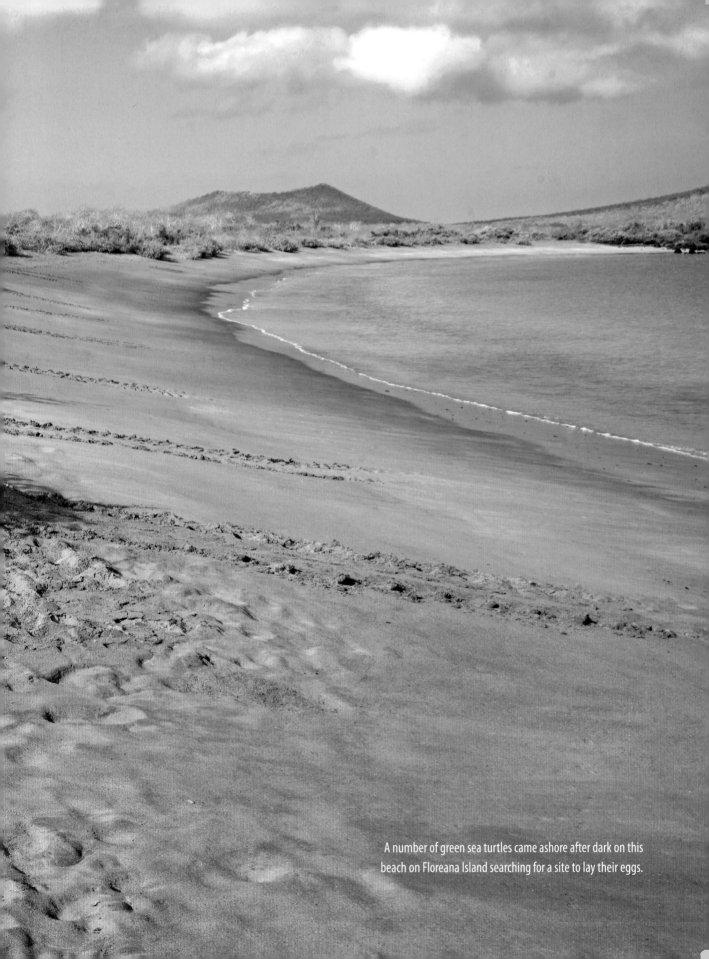

A number of green sea turtles came ashore after dark on this beach on Floreana Island searching for a site to lay their eggs.

females. Temperatures may vary within a single turtle nest. The eggs in the warmer center of the clutch will produce mostly females and those from the cooler outside area will hatch as males. Even the amount of shade and sunshine falling on a beach can shift the outcome of a clutch of eggs.

Long Live the Tortoise

The Galapagos giant tortoise is one of the best known of the islands' wildlife species. Tortoise symbols are used by many local organizations, and one is stamped in your passport by immigration officials when you arrive in the islands. The original ancestor of the giant tortoise arrived in the Galapagos 2 to 3 million years ago and, through the process of adaptive radiation, split into 16 separate species. Isabela Island has the greatest variety of tortoises, with a separate species on each of the

The front of the shell on a "saddleback" giant tortoise **(right)** is upturned, allowing it to stretch its neck upwards to reach flowers and fruits. A giant tortoise may wallow in mud **(below)** to protect itself from ticks and biting insects.

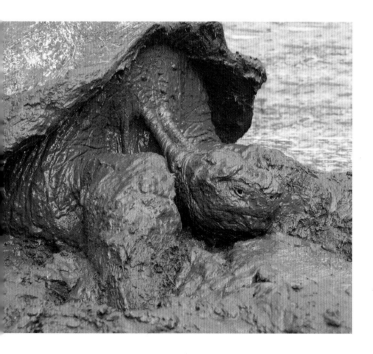

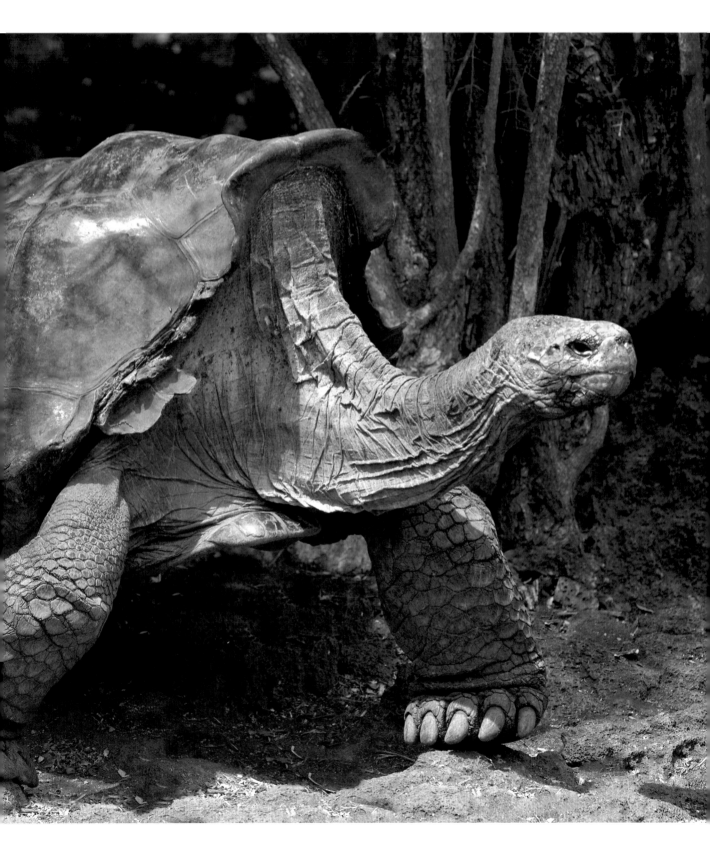

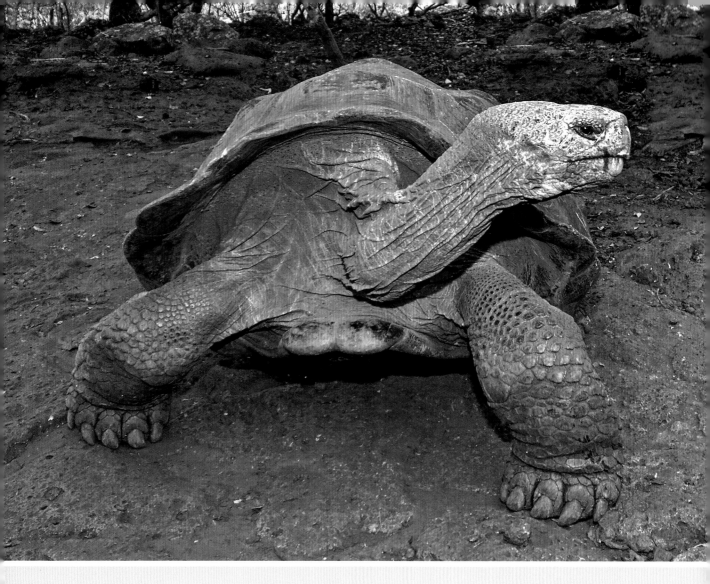

Tasty Ticks

Juicy blood-filled ticks and other skin parasites are a tempting meal for many birds, and in different parts of the world our feathered friends search for these tasty tidbits on the skin of animals. In North America, tick-infested moose attract gray jays, and in Africa, oxpeckers search the hides of zebras, gazelles, buffalo and giraffes for similar snacks. In all these cases the animals generally ignore the pecking birds. It's a different story with tortoises and ground finches in the Galapagos.

These two species actively communicate with one another — an amazing occurrence between creatures from such different branches of the animal kingdom. On Isabela one year, I watched the two species interact and recorded the event in my journal: "A large tortoise was blocking the trail as I came around a corner and a ground finch was hopping in front of it. Almost immediately the tortoise rose up on its legs as high as it could and stretched out its neck. It looked as if someone had inflated the creature with air and caused it to swell. With the tortoise elevated and its skin exposed, the finch began to search the many deep creases in the reptile's leathery hide. I didn't notice if the bird found any ticks to eat before it flew away. Moments later, the tortoise collapsed like a punctured tire."

island's five volcanoes. Barren lava fields surround the volcanoes, keeping the different tortoises isolated and preventing them from mixing with one another.

Since Darwin's visit to the islands, the shape of giant tortoise shells has been a source of much discussion. Their appearance varies between two extremes. Generally tortoises that live in the moist highlands, where the vegetation is thick, have large, dome-shaped shells that allow them to plow through the shrubbery without getting caught. These dome-shelled tortoises tend to be the heaviest of the species, weighing up to 250 kilograms (550 lb). As these heavyweights ram through the vegetation they create trails in the undergrowth. In the past these "tortoise highways" offered hungry pirates and whalers an easy way to penetrate the dense bush of the highlands and capture the defenseless tortoises more easily.

At the other extreme are the "saddleback" tortoises. In these the front of the upper shell is raised and

Giant tortoises with a dome-shaped upper shell grow larger than their saddleback relatives.

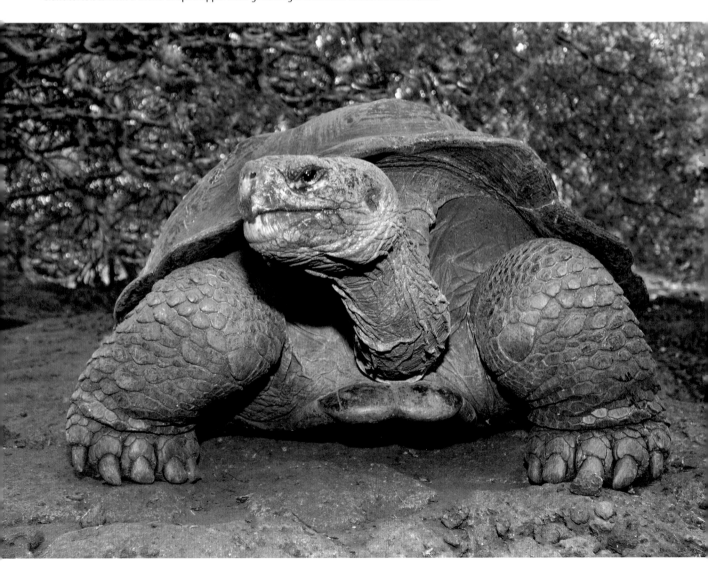

shaped like an old-style Spanish saddle, and their front legs and neck are longer than in the dome-shelled species. The saddleback tortoises typically live in the dry lowlands, where they must stretch to reach cactus pads and leaves high above the ground, extending their neck like a periscope and raising themselves as high on their legs as possible.

Giant tortoises live life in the slow lane, eating, sleeping and then eating some more. At night and during the heat of the day, they seek shelter under bushes and trees or in a muddy wallow. Soaking in a wallow insulates them against the chill of the night and may also bring relief from biting mosquitoes and ticks. Sometimes a dozen or more tortoises will soak in the same soupy wallow, like customers at an expensive health spa.

Some believe that the giant tortoise may be one of the longest-lived animals on the planet. The tortoise, like the green sea turtle, takes a long time to grow and mature, and it may not start to breed until it is 30 to 40 years old. Consider that a healthy young woman in North America can have a baby when she is just 13 or 14 years old and will live to be about 80. By comparison, a tortoise that starts to lay eggs at age 30 might live to be 160, and that is indeed what scientists currently estimate to be the maximum lifespan of a giant tortoise. Only two Arctic species live longer: the bowhead whale, with a lifespan of up to 200 years, and the Greenland shark, which can live for a remarkable 400 years.

Imps of Darkness

When dinosaurs ruled the world 150 million years ago, many species of reptiles lived in the oceans. Today among the world's roughly 10,000 reptiles, less than 1 percent live in the ocean. They include

During the breeding season, male marine iguanas on Espanola Island develop the most vibrant color change of any marine iguanas in the archipelago.

86

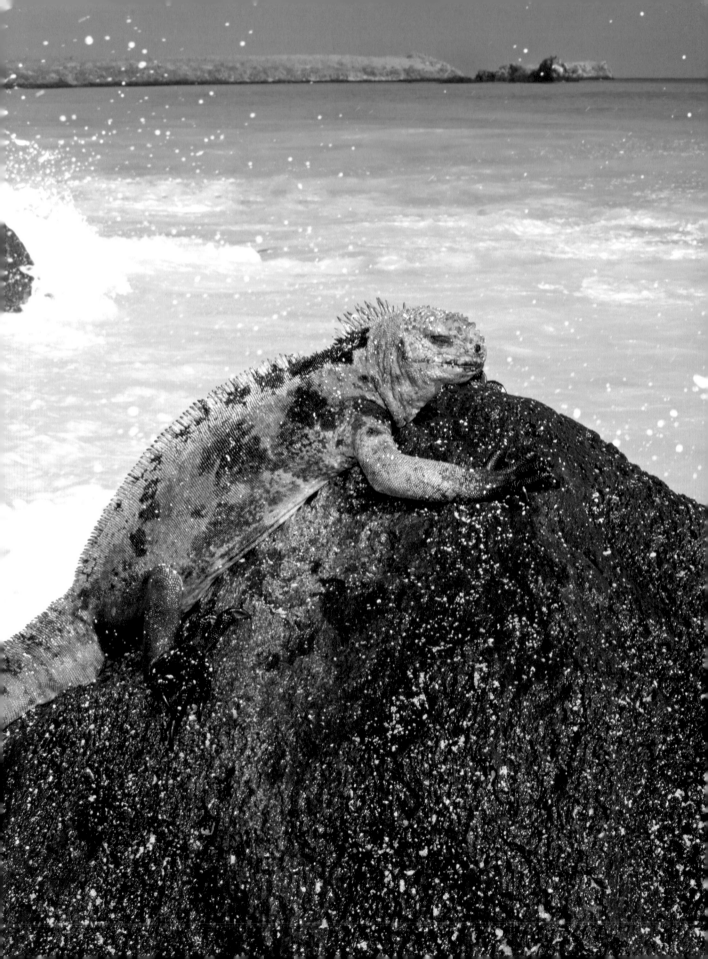

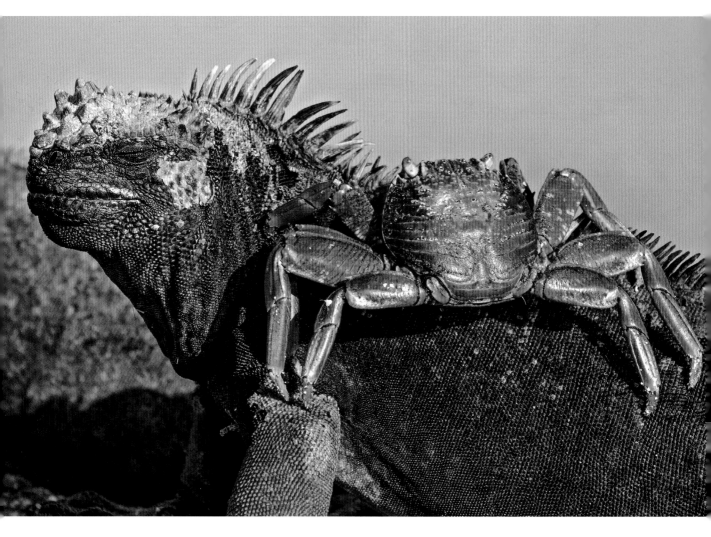

Sally Lightfoot crabs will sometimes climb over marine iguanas to feed on skin parasites.

7 species of sea turtles, 60 or so species of sea snakes, the saltwater crocodile and one species of lizard, the marine iguana of the Galapagos Islands.

The marine iguana is the one reptile that every tourist is guaranteed to see, feeding along innumerable rocky shorelines, crossing the road in the main town of Puerto Ayora or sunbathing on the rocks of every harbor. Hundreds, sometimes thousands, of marine iguanas may crowd together along a narrow stretch of coastline. Charles Darwin thought marine iguanas were clumsy and disgusting; he referred to them as "imps of darkness," as did many naturalists of Darwin's time. They had yet to appreciate the power and wonder of natural selection.

To make a living from the sea, the marine iguana evolved a fascinating array of adaptations. The main diet of this vegetarian iguana is green and red marine algae that grow on tide-covered rocks. The iguana has a flattened snout to get close to the low-growing plants it eats, and its teeth have multiple points to rake the algae loose.

Any animal that eats plants growing in the ocean naturally swallows seawater and must then clear

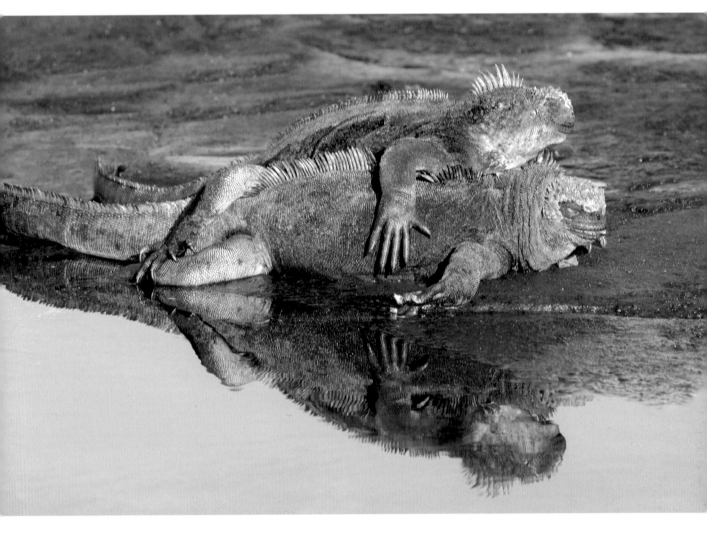

Marine iguanas conserve precious body heat by crowding close to each other.

its blood of excess salt. All marine reptiles have specialized glands in their head to get rid of this unwanted salt. In sea turtles the surplus salt is eliminated through their tears. Sea snakes flush it out with the flicking of their tongues, and marine iguanas sneeze it out through their noses.

To reach their food, marine iguanas need to be strong swimmers. All of them have a flattened tail for rowing through the surf and strong, curved claws for gripping wave-battered rocks covered with slippery algae. When iguanas are small, they usually stay in shallow water and feed on algae that gets exposed when the tide goes out. Larger individuals may dive for their dinner. While snorkeling I've watched marine iguanas dive 3 to 4 meters (10 to 13 ft) down and cling to algae-covered rocks in pounding surf. As they scraped their leafy meals off the rocks, the ocean swell would rock them back and forth. A shipmate of Darwin's tried to drown a marine iguana by tying it to a rock and throwing it overboard. To the sailor's surprise, the lizard was still alive an hour later.

Cold-blooded reptiles need to soak up heat from the sun to raise their body temperature in

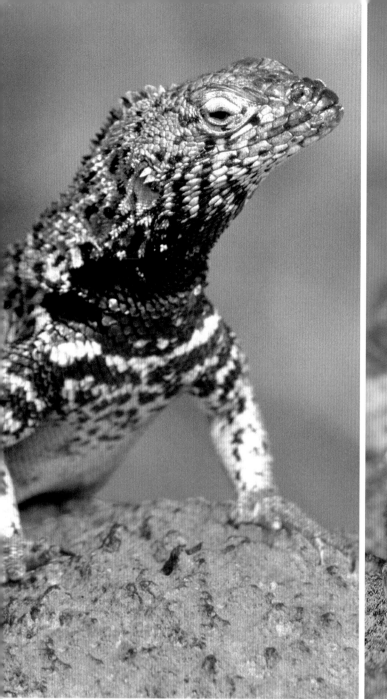

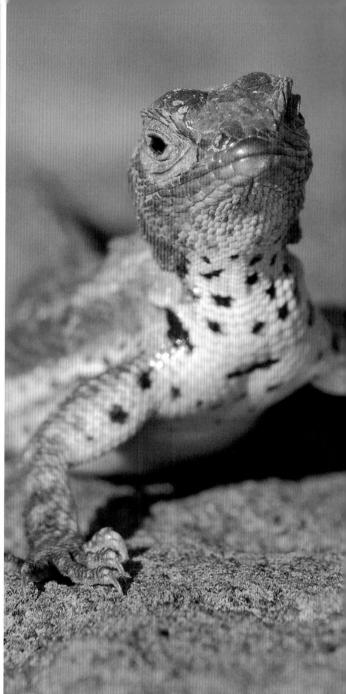

Pushup Power

Seven different species of lava lizards live in the Galapagos, with one on each major island. All the male lava lizards are tan-colored with scattered black spots, and some have a black throat. Female lava lizards usually have a showy orange throat. The most noticeable behavior of these little lizards is their curious pushups. No, they are not trying to get fit, but rather to warn their neighbors. Both sexes defend a territory against others of their own sex and perform pushups to discourage trespassers. When scientists filmed the lizards, they realized that the pushup patterns were different on each island.

order to move around and digest their food. After a large iguana heads out to sea on a diving trip, it must bask in the sun until its body reaches the ideal temperature of 37°C (98°F). During a dive the cold water quickly saps heat from an iguana's body, dropping its core temperature to 25°C (77°F). Smaller iguanas lose heat faster than large ones, and for this reason only the largest male marine iguanas dive offshore. Females and smaller males graze on algae-covered rocks exposed when the tide goes out.

Cactus Crunchers

Most land iguanas in the Galapagos live in the dry lowlands, up from the shoreline where marine iguanas cluster. Land iguanas are basically vegetarians, eating flowers, leaves and fruits. They are especially fond of the spiny pads and fruits of the prickly pear cactus. I once watched a land iguana try to grab a cactus fruit that was elevated just beyond its reach. After a couple of pitiful little jumps that failed, the iguana finally reared up on its hind legs. But its balance wasn't very good and it swayed unsteadily from side to side. Just as it was about to pluck its prize, it fell over backwards. I felt sorry for the hungry reptile and "accidentally" knocked the

The thick, juicy pads of prickly pear cactuses are one of the major foods of the Galapagos land iguana.

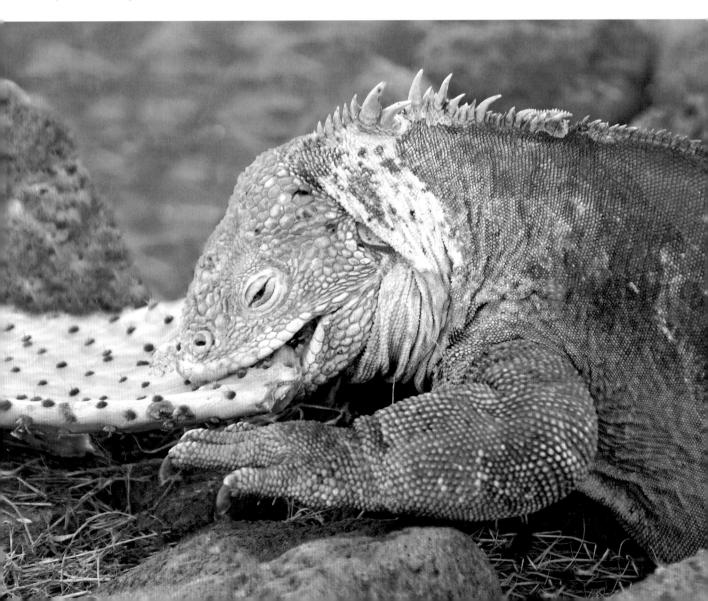

cactus fruit to the ground with the leg of my tripod — at least, that's how I explained it to the local naturalist guide.

The lining of a land iguana's mouth must be very tough, since the spines on a cactus pad are sharp and strong. Before it begins to eat, an iguana will often rough up the pad by rubbing it with its front claws to remove some of the spines. But even with this precaution, cactus-crunching iguanas swallow many spines, apparently without any injury to themselves.

Charles Darwin thought the land iguana had a "singularly stupid appearance." Iguanas, like many reptiles, are probably a lot smarter than most of us give them credit for, and they will take advantage of a novel meal when it arises. I've watched a land iguana tear pieces from the dry carcass of a dead pelican and another nibble on the afterbirth of a mother sea lion. Author William Beebe watched a land iguana chase a mockingbird holding a grasshopper in its beak. When the frightened bird dropped the insect, the iguana ate it immediately.

Worldwide, animals like the land iguana that live in drought-prone environments, where food is hard to find, are often quite flexible in their diets and readily exploit any source of nutrition they accidentally stumble upon. This is an example of how natural selection might work. In the past, land iguanas that were strict vegetarians and didn't scavenge or steal were more likely to die during a drought than the adventurous ones that tried new foods. The survivors then passed on that flexibility to their offspring, shaping the future behavior of their species.

Typically, a mature male land iguana defends a territory that includes several females. Males are easily identified by their greater size and more brightly colored appearance.

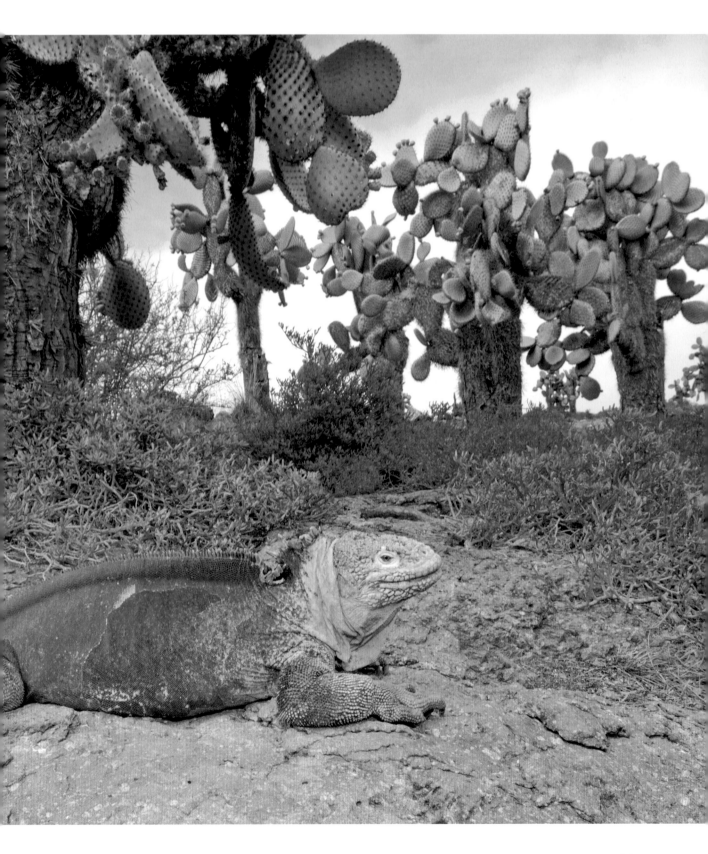

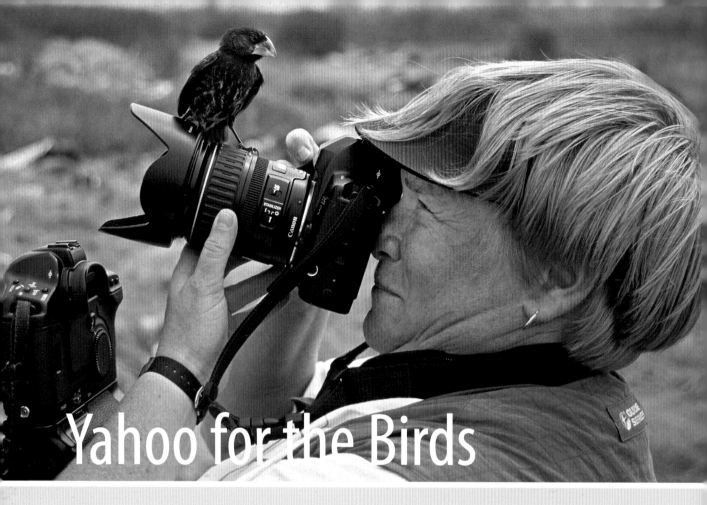

Yahoo for the Birds

Visitors to the Galapagos come for a number of reasons. Some come because of the evolutionary importance of the islands, others to scuba dive, and a few for the

dramatic volcanic landscapes, but most come to see the birds. There are fewer than 60 resident species on the islands, but roughly half of these are extremely rare and found nowhere else in the world. What makes a visit even more enticing is the fact that many of the birds in the Galapagos are delightfully unwary. They may perch on your head, tug at your shoelaces or ignore you when you are an arm's length away. The islands' birds can be roughly divided into land birds and seabirds, and in this chapter I will address the landlubbers.

The Flame-Birds

For me, the Caribbean flamingo is without question the most glamorous and colorful bird in the archipelago. It strides about in shallow saltwater lagoons and ponds on a number of the islands, but its numbers are scarce. In a 2015 census, researchers counted just 342 flamingos in 19 ponds and lakes. The birds move around frequently, so it's a lucky day when you see one.

Flamingos are filter-feeders, just like baleen whales. The birds strain tiny shrimp, water boatmen and other aquatic insects from the salty waters in which they feed. They use their tongue like a plunger to suck water in through the sides of their beak and then pump it out again, straining out any tiny animals. When feeding, a flamingo swings its upside-down head from side to side, often stirring up the bottom with a foot to flush out insects hiding in the mud.

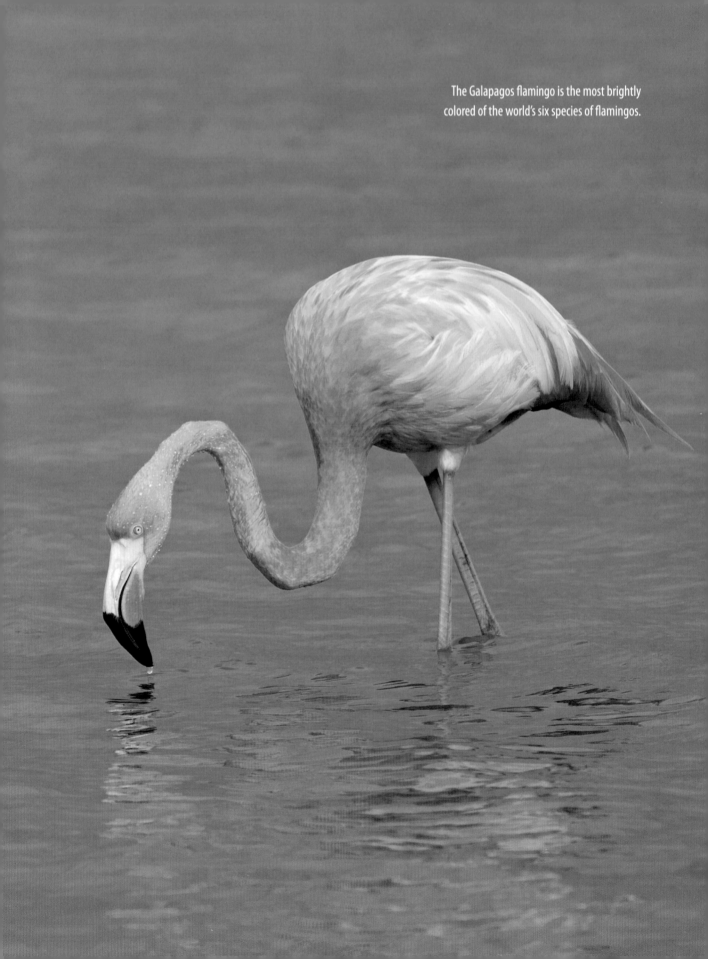

The Galapagos flamingo is the most brightly colored of the world's six species of flamingos.

For the longest time flamingos (**above**) were thought to be closely related to waterfowl. Now, after recent genetic studies, scientists believe their closest relatives are grebes. The endemic Galapagos hawk (**opposite page**) will readily feed on carrion and commonly scavenges the carcasses of sea-lion pups that die in early life.

The bird's alluring pinkish-orange feathers may be a way for it to advertise its health and vitality to future partners. The color comes from pigments in the tiny animals they eat. When a flamingo is sick, its feathers fade, revealing to possible mates its unhealthy condition.

Hunters in Daylight and Darkness

The Galapagos hawk must be the tamest hawk in the world. Darwin remarked: "A gun is here almost superfluous; for with the muzzle I pushed a hawk off the branch of a tree." On various occasions curious young hawks have flown over and perched near me for a closer look, once even landing on my tripod.

The hawk is the main daytime bird of prey in the islands, targeting virtually any creature that moves, including nesting female marine iguanas, lava lizards, baby tortoises, snakes, rice rats, swallow-tailed gull chicks, young boobies, songbirds and even centipedes and grasshoppers. The Galapagos hawk,

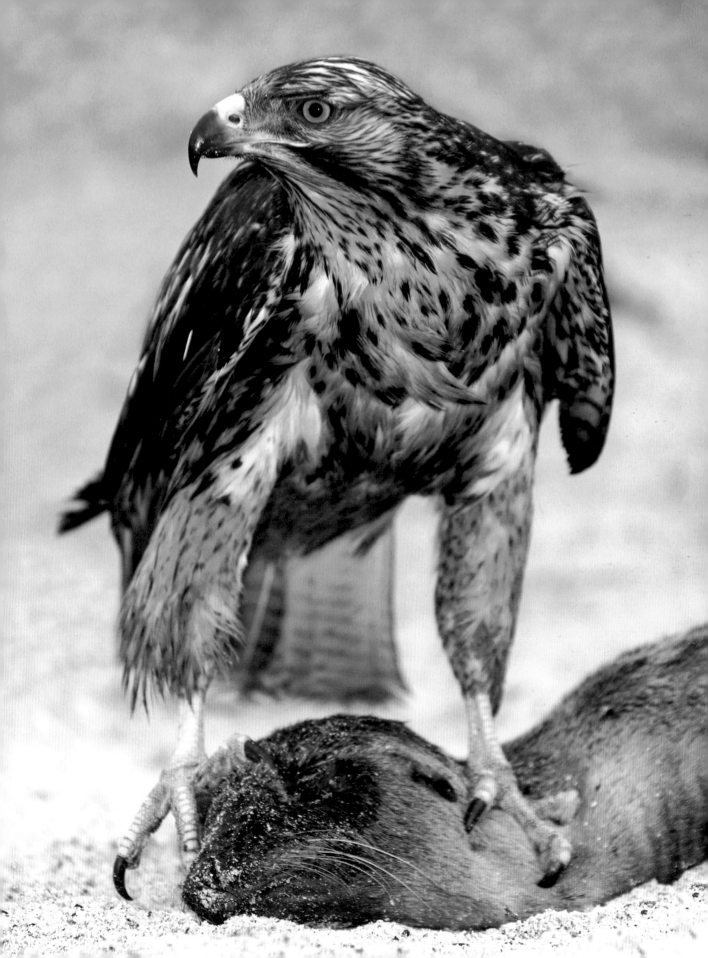

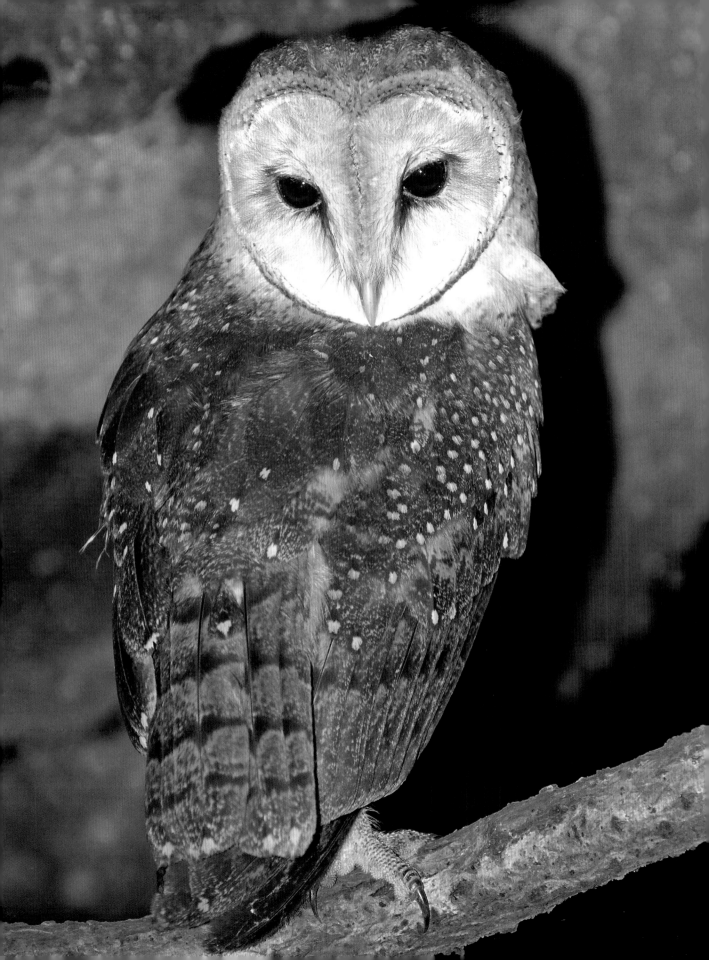

The barn owl **(opposite page)** commonly nests in rock cavities and abandoned buildings and feeds on insects and small rodents. In the Galapagos, the short-eared owl **(above)**, normally a nocturnal hunter, will hunt during the day when there is no competition from daytime-hunting hawks.

like many birds of prey, will also scavenge a dead sea lion, seabird or whale that gets washed ashore.

Biologists believe that the Swainson's hawk of North America is the most likely ancestor of the Galapagos hawk. According to genetic studies, the hawk arrived in the islands 126,000 years ago. Swainson's hawks spend the summer months on the prairies of Canada and migrate south to the pampas grasslands of northern Argentina for the winter — the longest migration of any hawk in the Americas. It's easy to imagine that a few ancestral hawks, or at least one pair, were blown off course by a strong storm and ended up colonizing the islands.

The mating system of the Galapagos hawk is one of its unusual traits. In most hawk species a male and female form a temporary partnership and raise a family of chicks together. With the Galapagos hawk, one female mates with multiple partners, sometimes as many as eight. When the female lays her two eggs, none of the males knows for sure which one of them is the father, so they all bring food to the nest, just in case the chicks are indeed theirs.

Though the daytime belongs to the Galapagos hawk, the night belongs to two species of owls.

The barn owl and the short-eared owl have the greatest ranges of any owls in the world, so it's not too surprising that both were able to colonize the Galapagos. The distance between the islands and the mainland is the farthest ever traveled by an owl blown offshore by a storm that survived the ordeal. Biologists call the two owls "tramp species" because both are very flexible in their behavior and able to settle in a wide range of different habitats, where they hunt a great variety of prey.

Perhaps the most unexpected prey I saw a short-ear hunting were storm petrels on Genovesa Island, where immense numbers of these "sea swallows" nest in crevices in the rocks. In the course of about 20 minutes I watched a hunting short-eared owl walk around the lava surface and peer into several cracks, searching for a defenseless petrel it could reach. Finally it simply stood beside a likely crevice and waited patiently. After about 10 minutes an unsuspecting storm petrel flew out, and the owl caught it with a lightning strike of its taloned foot.

Darwin's Famous Finches

Darwin's finches are the rock stars of the Galapagos; more has been written about them than perhaps any other group of creatures on the islands. Few biology textbooks fail to mention the finches when discussing the concept of evolution, which the

The heavy beak of the large ground finch (**below**) enables it to crack the toughest of seeds whereas the pointed beak of the cactus finch (**opposite page**) is suited to probe the flowers and fruits of cactuses.

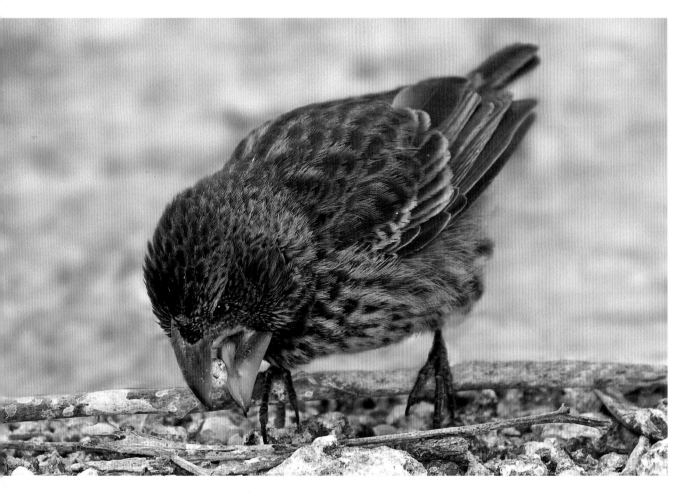

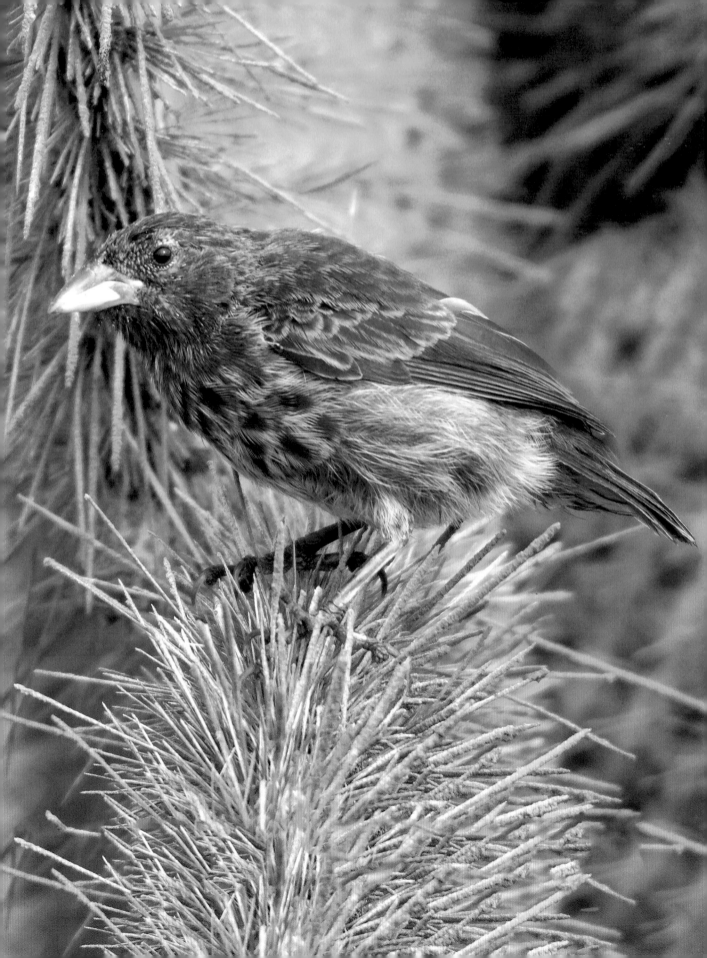

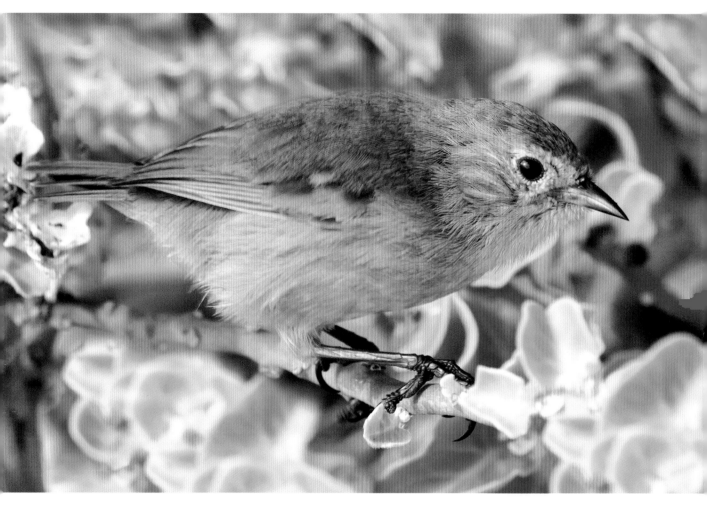

It is likely that the warbler finch most closely resembles the ancestral finch that radiated to becomes the 14 species of Darwin's finches we have today.

brilliant Oxford scientist Richard Dawkins calls "the greatest show on Earth." Contrary to popular belief, while Darwin was in the Galapagos he didn't think the finches were important. He even misidentified some of them as blackbirds, wrens or warblers. It was only after his finch collection was analyzed by a specialist in London that he learned that the birds were closely related species.

The ancestral finch colonized the islands roughly 2 to 3 million years ago. Biologists believe that the initial colonists were a single species of finch, perhaps a small group of them blown in by a storm, or maybe a single egg-bearing female. This single species of finch ultimately evolved into 14 separate species. Thirteen of these now live in the Galapagos Islands and one lives on distant Cocos Island, near Costa Rica.

The Galapagos finches can be broadly broken into three groups: six species of ground finches, six species of tree finches and a single warbler finch. Darwin's finches are strikingly similar, with only subtle differences in their plumage and beaks. It is those slight differences in the shape of their beaks, however, that allowed the birds to evolve into so many different species that feed on so many different foods. Certain finches eat soft seeds while others

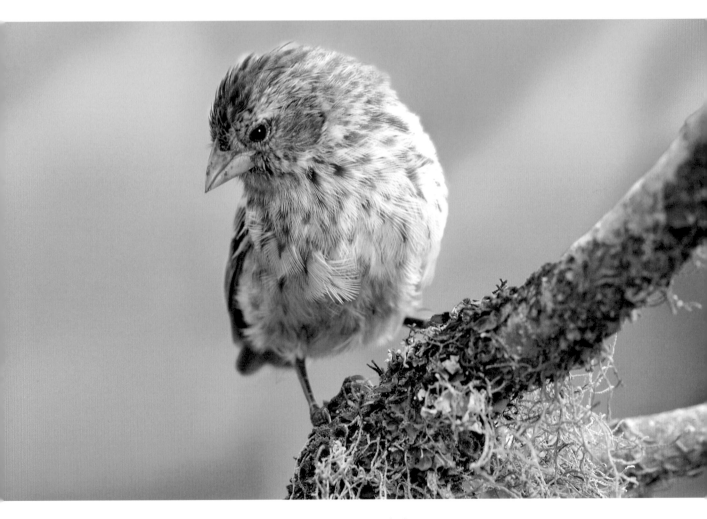

The streaky breast and pointed beak identify this bird as a female medium tree finch.

eat seeds that are as hard as stone. Some eat insects, some pluck ticks from tortoises and some eat leaves and fruits. Others eat flowers, some crack seabird eggs and eat the drippings, and some behave like feathered vampires, pecking the skin of seabirds at the base of their feathers and sipping the blood that oozes out. The mangrove and woodpecker finches specialize even further, using cactus spines and twigs to dig beetle larvae from their holes in dead trees.

Darwin's finches have adapted not only their diet to the extreme climate of the islands but their breeding biology as well. As previously discussed, the rainfall season in the islands varies greatly as to when it begins and ends and how much moisture falls. Finches breed in the rainy season, and if they are to do so successfully they need to breed rapidly; indeed, they may begin to lay eggs within a week of the start of the rains. Compared to mainland finches, those in the Galapagos lay large numbers of small eggs that hatch quickly, after 12 days. In a wet year a mother finch may lay a second clutch of eggs in a second nest, even before her first family of chicks has left the first nest. In an El Niño year (which can be very wet) a female may nest multiple times and produce up to 20 nestlings in a five-month period.

Splendid Seabirds

Roughly three-quarters of our world is covered by seawater. Some people suggest that we actually live on Planet Ocean rather than Planet Earth, but of the 10,000

species of birds in the world, only 300 species — 3 percent — are seabirds. Seabirds spend most of their time at sea, where they feed, and they come to shore only to lay their eggs and raise a family. In the Galapagos, seabirds are the celebrities of the archipelago. Most are big, conspicuous and trusting, allowing visitors to observe them at close range.

Beating the Heat

Many people are surprised to find a penguin living on a tropical island. The Galapagos penguin is the only member of the penguin family that lives on the Equator. As a member of a family of seabirds that evolved in cold polar seas, the Galapagos penguin adapted to an environment of intense sun and heat.

One way to adapt to life in the tropics is to have a small body size. The Galapagos penguin is considerably smaller than its ancestor, the Humboldt penguin, and is the second-smallest penguin in the world; only the little penguin of Australia and New Zealand is smaller. A small body has a relatively large surface area, which allows a bird to lose body heat more easily, thus preventing it from overheating.

All penguins have a continuous covering of feathers, which is good insulation in cold water but can lead to overheating when they are on land. To cool themselves, Galapagos penguins move blood to areas of bare skin on their face, like joggers ending up with flushed faces when they exercise. The Galapagos penguin has more bare skin on its face

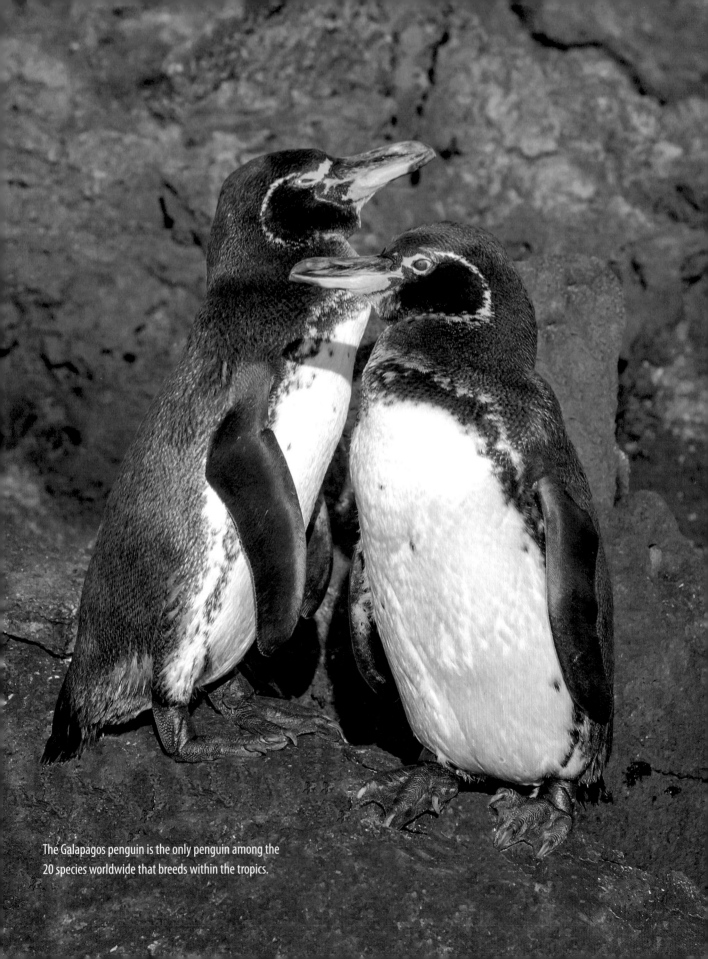

The Galapagos penguin is the only penguin among the
20 species worldwide that breeds within the tropics.

than other penguins do.

Another way that Galapagos penguins avoid overheating is by hiding in cool caves and crevices in old lava beds. The surface temperature of black lava rocks can sometimes exceed 50°C (122°F), hot enough to fry an egg. By sheltering and nesting in crevices, where it is cooler, penguins can protect themselves, their eggs and their chicks from dangerous overheating.

Most Galapagos penguins live on the western side of the archipelago, where the cold waters of the Cromwell Current cool the coastline. During an El Niño year, warm currents overwhelm the islands. Food for penguins and most other seabirds becomes scarce and many are unable to breed or even to survive. During the 1982–83 El Niño, 77 percent of the Galapagos penguins died from starvation, and during the 1997–98 El Niño, 65 percent died. Darwin was a sharp-eyed observer but he failed to mention seeing a penguin, though he sailed through the waters where Galapagos penguins are most

(Right) Galapagos penguins commonly forage in small groups in shallow water, targeting small schooling fish. **(Below)** Most dives are in water less than 6 meters (20 ft) deep and last less than a minute.

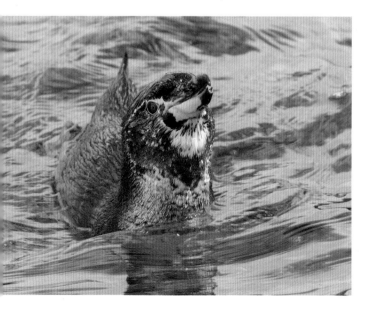

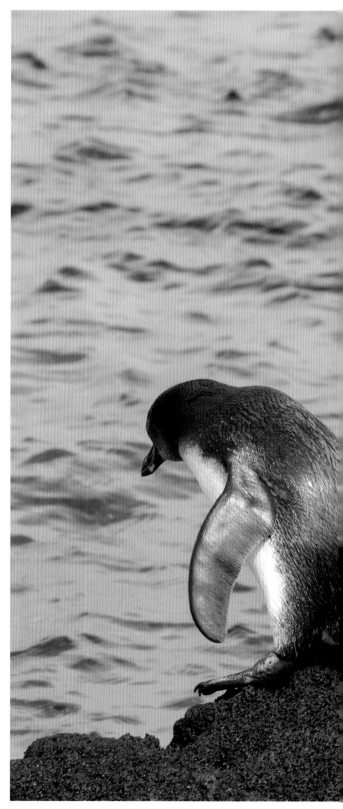

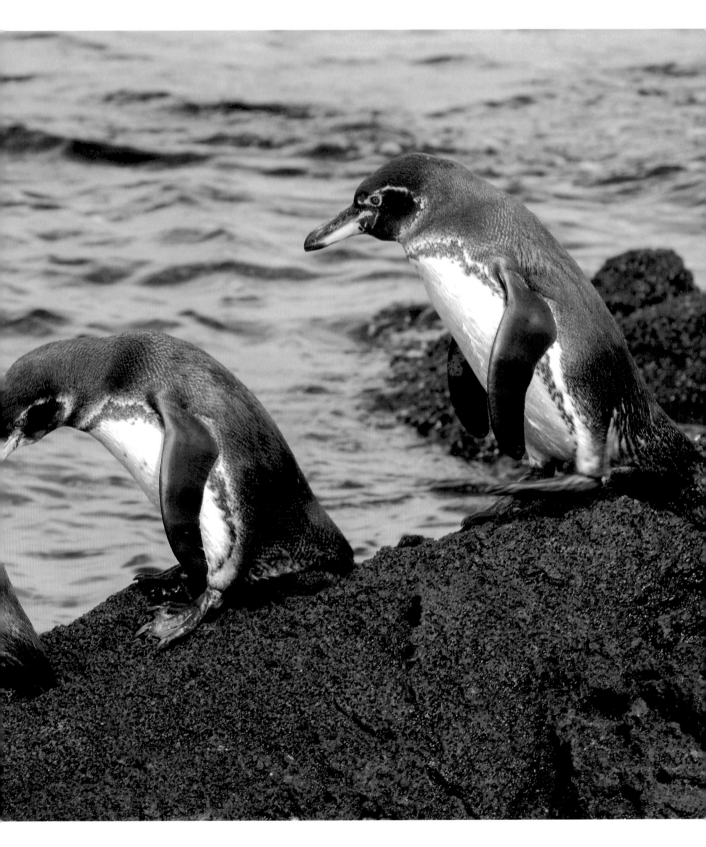

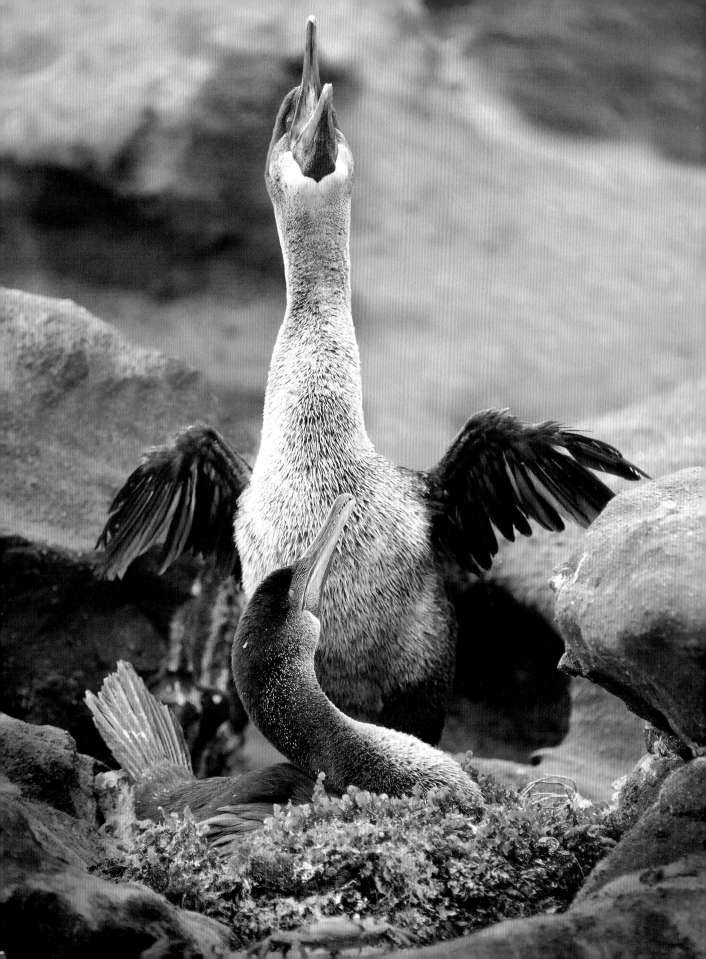

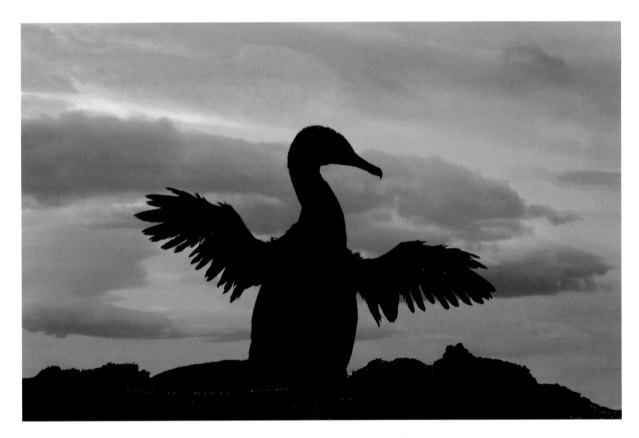

abundant today. Perhaps an earlier El Niño year had killed many of them off.

Recurrent El Niños drastically limit the penguin population, so when conditions improve, the birds may breed twice in one year, and even up to three times in 15 months. Today the Galapagos penguin population hovers around 1,500 birds and is highly vulnerable to global warming. Scientists predict that in years to come, El Niño events will become more frequent and more severe as the planet warms, and this could possibly lead to the penguin's extinction.

Earthbound Divers

Snorkeling in the Galapagos brings many surprises. When a flightless cormorant dives, it leaves behind a trail of silver bubbles as the air is squeezed from its feathers. On one dive I watched a cormorant catch a small octopus, which wrapped its arms so tightly around the bird's face that the cormorant couldn't see where it was swimming. When the cormorant released its grip, the octopus tried to jet away but was captured again.

The most noticeable feature of the Galapagos cormorant is its pitiful, scraggly wings. Among the 38 cormorant species in the world, the Galapagos cormorant is the only one that doesn't fly. Flight-lessness in birds is relatively rare, existing in less than 1 percent of all birds worldwide; penguins and ostriches are two of the most famous examples.

Why would any bird give up an ability as valuable as flight? There must be strong benefits for it to evolve that way, and indeed there are. Flight muscles can make up nearly a third of a bird's total body

The wing feathers of the flightless cormorant **(above)**, like those of all cormorants, get soaked when it swims and need to be dried afterwards. A cormorant nest **(opposite page)** consists of seaweed, sticks and bones.

The feathers of this six-month-old albatross chick became matted and disheveled after a heavy rainstorm.

itself. When flight is no longer necessary, a bird can grow larger. Larger birds can dive deeper and stay underwater longer than smaller ones can. Not surprisingly, the flightless cormorant is the largest cormorant in the world, weighing up to 4 kilograms (9 lb) — roughly twice the weight of most cormorants that do fly. With a larger body size, the flightless cormorant can tackle larger fish. This reduces competition with its neighbor the Galapagos penguin, which also hunts underwater but feeds on much smaller fish.

The flightless cormorant, like the penguin, is impacted greatly by El Niño events. During minor warming episodes they may stop courting and laying eggs, and if the El Niño is severe, many may starve to death.

Masters of the Wind

Albatrosses are among the greatest of the soaring birds. They glide tirelessly over the windiest latitudes on Earth, especially between 40 and 60 degrees, the so-called "roaring forties" and "furious fifties." The waved albatross of the Galapagos is the most tropical of its kind and the only one to live on the Equator. Virtually all 15,000 to 18,000 pairs of waved albatrosses in the world nest on Espanola Island in the Galapagos.

As with every seabird that lives in the unpredictable waters surrounding the Galapagos, the albatross must adjust its life cycle to the local conditions. It takes roughly nine months to raise a single albatross chick, from the time the egg is laid in April until December, when the chick becomes independent. When the chick is a small, fuzzy gray bundle of down and can't be left alone for long, the parents find enough food in the nearby waters of the archipelago to satisfy its appetite. However, once it gets bigger and needs more food, both parents must travel far from home to the rich waters off the coast of Peru — a round trip of up to 3,000 kilometers

weight, and those muscles take a lot of energy to maintain. In the rare circumstances where flight is unnecessary for everyday life, it makes sense to stop flying and let the muscles shrink, saving energy in the process.

Flight in birds is one of their best defenses against predators. In the Galapagos the cormorant has no predators, so it doesn't need to fly to protect

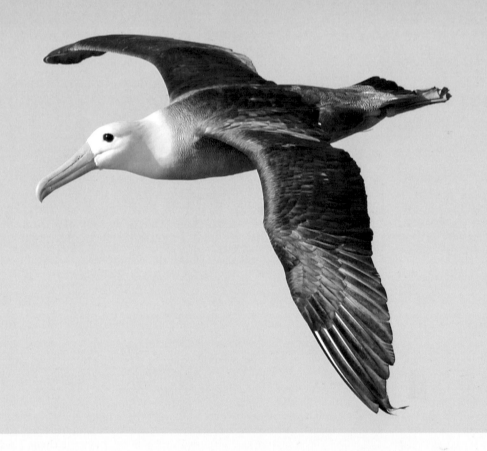

Although the male waved albatross **(above)** is slightly heavier than the female, their wingspans are a similar 220-250 cm (87-98 in). Albatross courtship sessions **(below)** with bowing, nodding, sky-pointing and bill rattling may involve trios or even quartets.

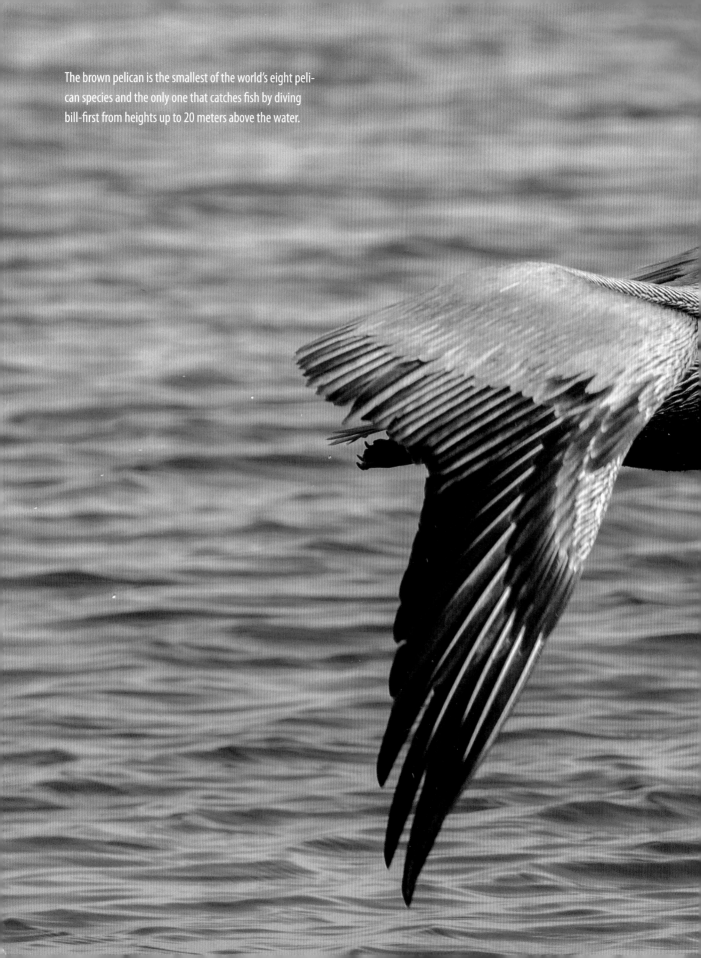

The brown pelican is the smallest of the world's eight pelican species and the only one that catches fish by diving bill-first from heights up to 20 meters above the water.

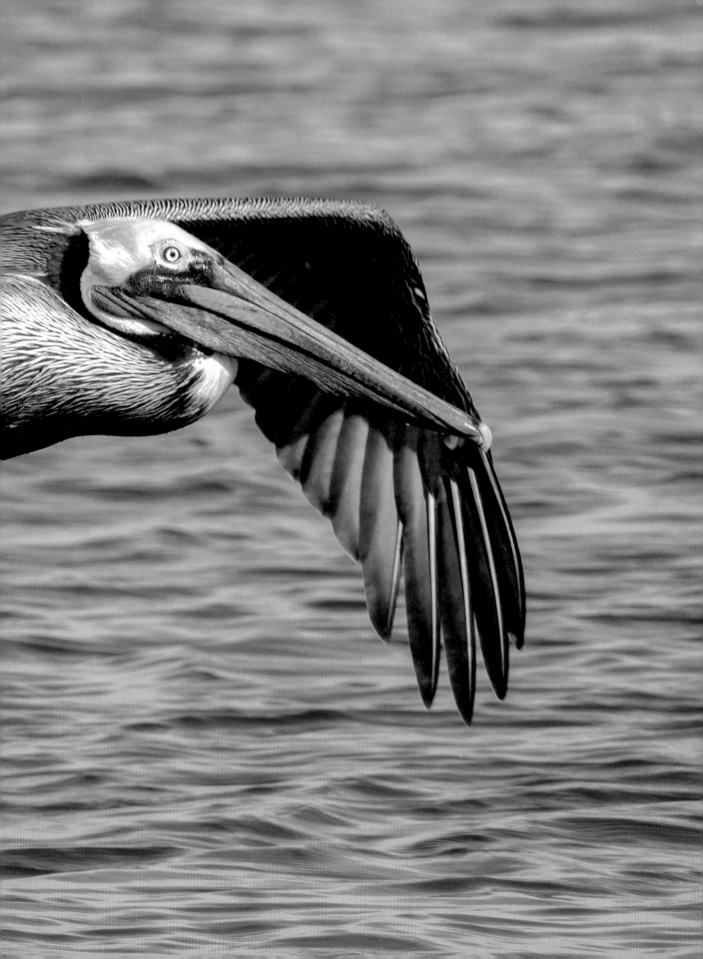

(1,860 mi). On the Peruvian coast the adults feed on squid and fish for up to two weeks before catching a tailwind that will propel them back to the islands in as little as four days. In their bellies they carry some fresh seafood as well as an energy-rich soupy oil derived from the krill, fish and squid they've eaten. This stomach oil is lighter to carry than undigested fish and squid.

While the parent albatrosses are away on the coast of South America, the chicks often cluster together in "nursery groups," frequently in the shade of bushes. The adults find their chick by calling back and forth. The hungry chick, always eager for another meal, responds as soon as it hears its parents call. During feeding, a parent may regurgitate up to 2 kilograms (4.4 lb) of fresh seafood and stomach oil into the mouth of its chick. Afterwards, the overstuffed young albatross is visibly swollen and sometimes unable to stand properly, so it waddles around on its ankles.

By December the chicks are the same weight as or heavier than their parents. They eventually leave the islands on their own and disappear out to sea. From then on they live without guidance, directed solely by the genetic instructions inherited from their parents. Newly independent albatrosses remain

The raised scapular feathers on a displaying magnificent frigatebird emphasize the feathers' greenish-blue iridescence.

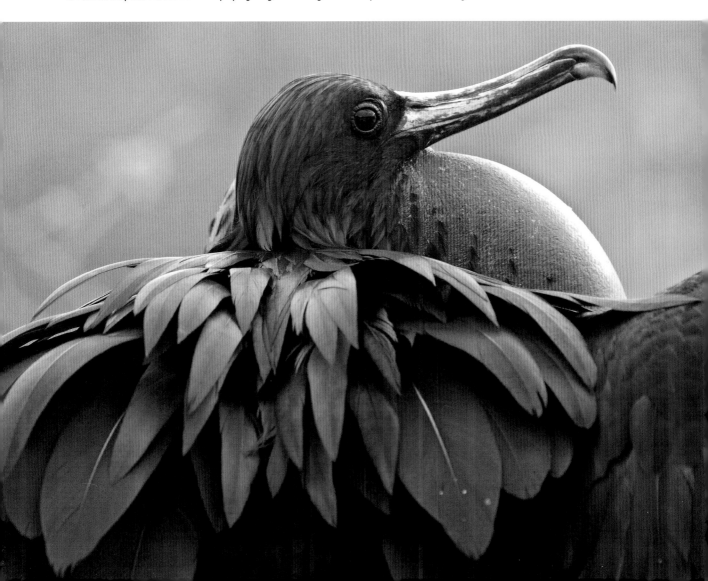

at sea until they are four or five years old, at which time they will return to land and breed as adults.

Pirates with Wings

Birds that specialize in stealing food from other birds are called kleptoparasites — in other words, avian pirates — and none are better at this than frigatebirds. Two species nest in the Galapagos, the great frigatebird and the magnificent frigatebird. Both chase gulls and boobies to steal their catch when they return from a fishing trip, sometimes forcefully tugging on their tail or wingtips, trying to bully them into throwing up a swallowed meal in midair. The successful thief then swoops down and retrieves the vomited fish or squid before it hits the water.

Frigatebirds make their living from the sea but they are seabirds with a difference. They can't dive underwater, nor can they swim on the surface; they can't even float well. In fact, if a frigatebird lands on the water, it can't take off again and eventually drowns. But what a frigatebird lacks in aquatic skills it makes up for in flying ability: these birds are aerial experts. Frigatebirds use their aerial agility not only to steal food from other seabirds but also to pluck flying fish from the ocean's surface without wetting a

Great frigatebird chicks grow slowly and may stay in the nest for up to seven months.

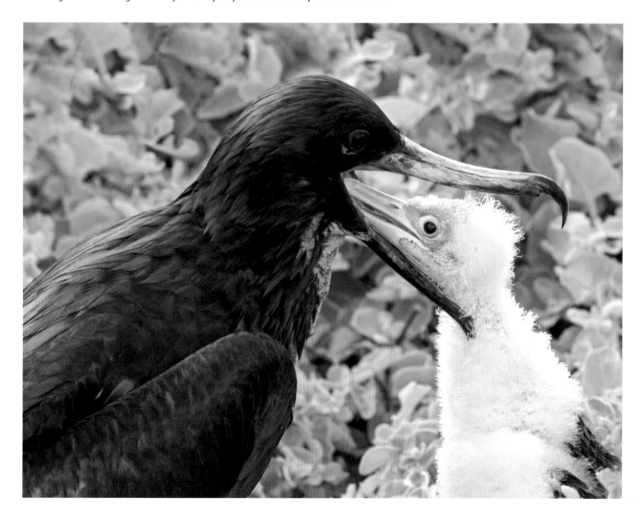

feather and to skillfully snatch baby sea turtles from a sandy beach with never a miss.

Frigatebirds are such good flyers for a couple of reasons. They have large wings, spanning up to 2.5 meters (8 ft), and are surprisingly lightweight because their bones are filled with numerous air pockets. The combination of large wings and low body weight translates into ease of flying and effortless soaring. The result for the frigatebird is a lifestyle that requires less food to survive.

Even when frigatebirds can steal food from other birds, a life of piracy is usually one of feast or famine, so they need to keep their energy costs as low as possible. In a bird's life, energy is burned in three ways: searching for food, maintaining their feathers and raising a family. As discussed above, flying and searching for food takes remarkably little energy for a frigatebird because of its low body weight and large wings.

Feather care is a second way in which frigatebirds reduce their energy costs. Using their beaks, seabirds typically paint their feathers with oil from a preen gland at the base of their tail. This serves to waterproof their feathers, but producing preen oil takes energy, so frigatebirds have a relatively small preen gland. Although this saves them energy, with less oil to protect their feathers the birds are susceptible to waterlogging. They quickly get soaked in the rain and can never land on the water, because they would drown.

Frigatebirds also adjust to their low-energy lifestyle when raising a family. They have one of the longest breeding cycles of any seabird, sometimes taking more than two years to raise a chick. The pair incubates a single egg for up to 55 days and may spend another seven months feeding the chick at the nest. Because it is hard for the parents to find food,

Typically, the great frigatebird, like all frigatebirds, nests in colonies, with pairs sometimes just a few meters apart.

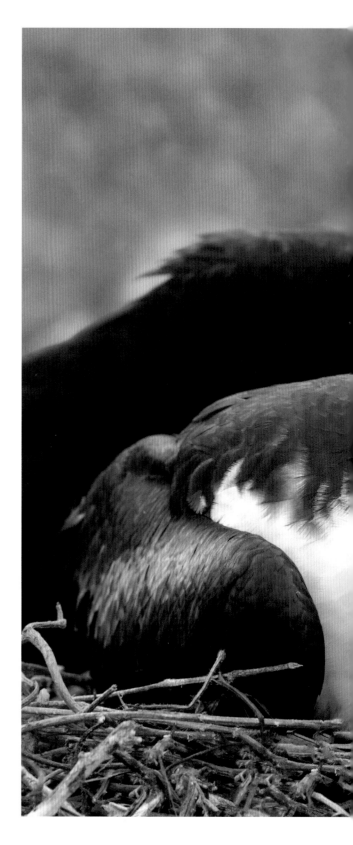

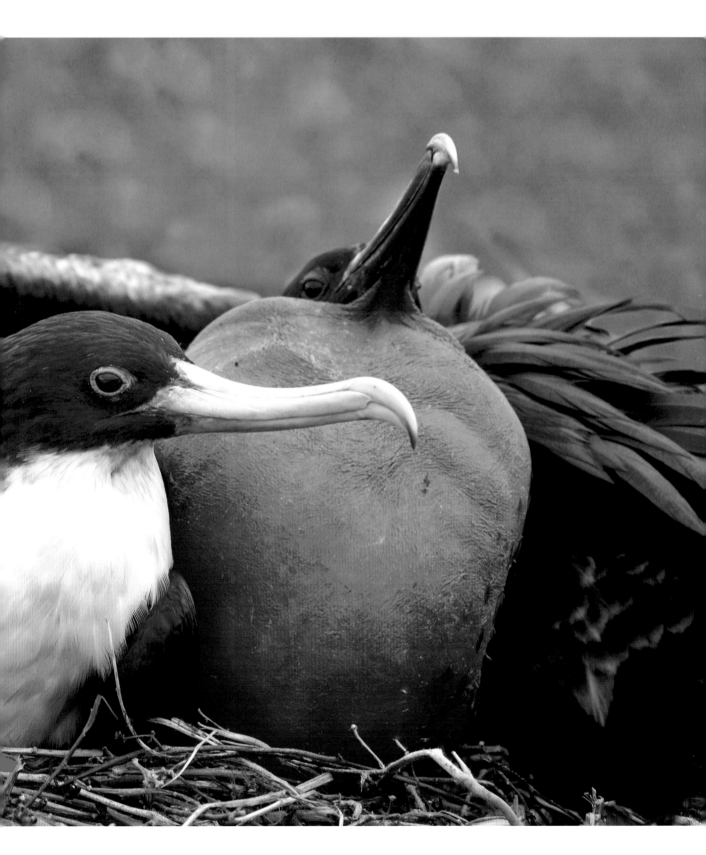

117

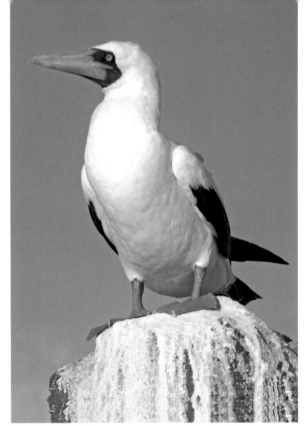

they may feed their chick only once every three days. This slows down the chick's growth and determines how late it can leave the nest. Frigatebirds also continue to care for their chicks after they begin to fly — up to 18 months, the longest of any seabird. Young frigatebirds need to depend on their parents this long because piracy and their style of fishing are difficult skills to learn.

Booby Bonanza

In Spanish, the word *bobo* means "clown" or "fool," and this may be where the seabird name "booby" originated. In earlier times, pirates and whalers thought these birds were stupid or foolish because they were so easy to approach and catch. Three species of boobies — the red-footed, the blue-footed and the Nazca — live in the Galapagos. Their large size, unwary nature and dramatic behaviors make them regular favorites among visitors.

The boobies are superbly adapted seabirds that "plunge-dive" to catch their fish dinners. They start a dive up to 100 meters (300 ft) above the water's

surface. As they nosedive they pick up speed and tuck in their wings. When they finally strike the water, they may be traveling at 100 kilometers per hour (62 mph).

To perform such remarkable dives without getting injured, boobies have evolved a number of diving adaptations. Their dagger-shaped beak allows them to penetrate the water more easily and reach greater depths, sometimes down to 15 meters (49 ft). Most birds have nostrils at the base of their beak. If boobies did as well, they would get an instant brainwash when they hit the water at speed. Instead of using nostrils they breathe through their mouth, and they keep their mouth shut tightly when they dive. As well, the visual fields of a booby's eyes overlap above the top of its beak, giving the bird greater depth perception and a greater ability to

The red-footed booby **(opposite page)** is the smallest of the Galapagos trio of boobies. The blue-footed species **(above left)** is intermediate in size and the Nazca **(above right)** is the largest. In all three species, the females are bigger and heavier than the males.

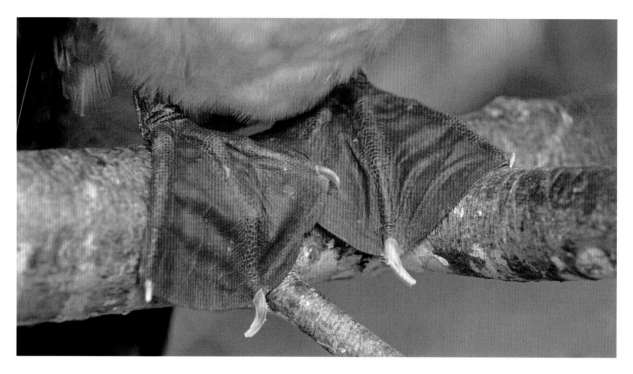

The color intensity in a booby's feet is a reliable cue to the bird's health and freedom from parasites.

lock on to a target. Not surprisingly, boobies have a reinforced skull to shield their brain from injury and protective air sacs in their neck and chest to cushion the impact when they hit the water in a power dive.

With three species of closely related seabirds occupying the same general area, they must lessen the competition between them. Here's how Galapagos boobies can coexist: Although all three boobies feed on fish, they hunt in very different areas of the archipelago. The red-footed booby scans the seas beyond the outer edge of the islands, often hunting at night. The blue-footed booby forages close to shore, often in water less than a meter (3 ft) deep. To prevent itself from crashing into the bottom in such shallow water, the blue-foot has a long tail that helps it to swerve quickly underwater. The Nazca booby forages in the deeper ocean areas between the islands.

When it comes to nesting, the three species differ as well. The red-footed booby gathers sticks and makes a rough nest in the branches of a mangrove tree, whereas the blue-footed booby nests in open areas on bare flat ground, making a simple scrape and sometimes adding a few twigs. The Nazca booby also lays its eggs on the bare ground, but in more vegetated areas and often on slopes.

Nest location can determine how elaborately a bird displays in courtship. The tree-nesting red-footed booby woos its mate in a confined area and its displays are fairly simple. In contrast, the blue-footed booby, which has a flat, open stage to show off on, has the most impressive displays of the trio. When blue-foots "sky-point" they lift their beaks sharply upwards, flare out their wings and strut around, lifting their big, colorful blue feet like clowns with floppy oversized shoes. Nazca boobies have less space in which to court; in their version of sky-pointing they don't flare their wings as much.

Egg-laying also varies among the three. Red-foots lay just one egg, the Nazca two eggs, and blue-feet

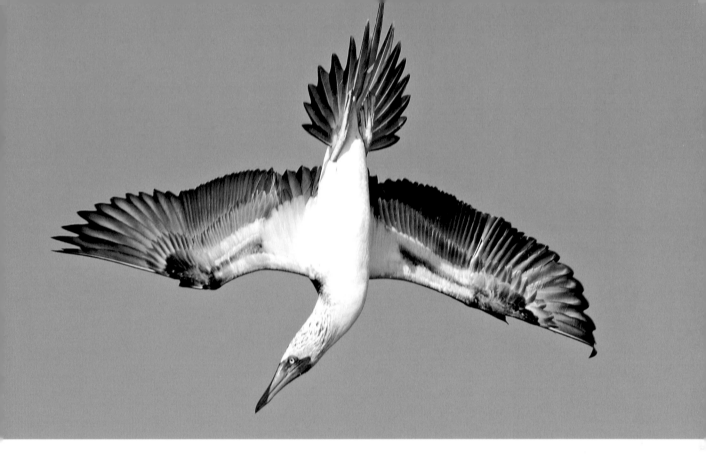

At the top of a dive **(above)** a blue-footed booby may be 100 meters (330 feet) above the water. Because the blue-footed booby nests on the ground in the open, males have more space for elaborate courtship displays **(below)**.

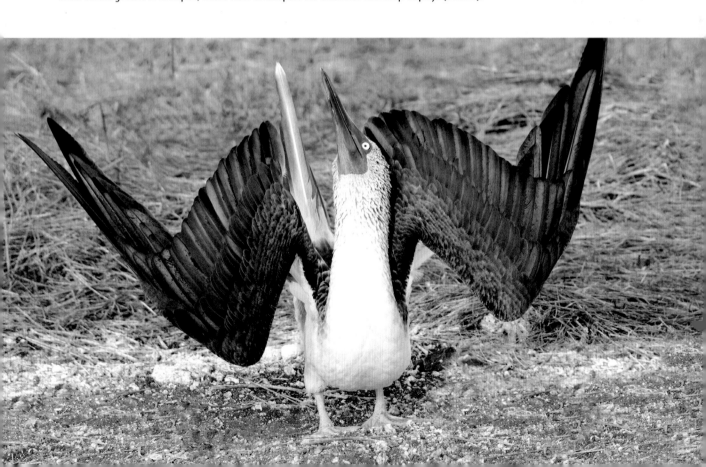

two to three eggs. Where a booby hunts in the ocean determines how many chicks it can feed. The blue-footed booby fishes close to shore, so it travels only a short distance from its nest. This allows it to make frequent trips to satisfy its hungry chicks, commonly two to three times per day. The red-footed booby, which hunts far offshore, has the longest distance to travel. It is able to raise only a single chick, feeding it just once every one or two days.

Most birds have a bare patch of skin on their stomach for warming their eggs, but boobies warm their eggs with their large webbed feet, which they flood with blood to provide the necessary heat. A booby's large, colorful feet are not only a handy source of body heat but also a visible indicator of the bird's health and vitality. Scientists have shown that potential mates check out each other's foot color when selecting a partner, because healthy birds have the most colorful feet.

Perhaps the most chilling aspect of life in a booby family is the killing of one chick by its brother or sister. Of course, the single chick in a red-foot family does not have this problem, but with blue-feet one chick may kill its sibling when food is scarce. In the case of the Nazca booby, the larger chick *always* kills its smaller brother or sister, even when there is enough food for both. The killer pecks its sibling repeatedly or drives it out of the nest area, where it starves. Why then, if you are a Nazca booby, lay more than one egg? Perhaps Nazca boobies are actually only able to raise a single chick and the second egg is simply insurance in case the first egg fails.

Only in 2002 was the Nazca booby of the Galapagos recognized as a separate species distinct from the lookalike masked booby.

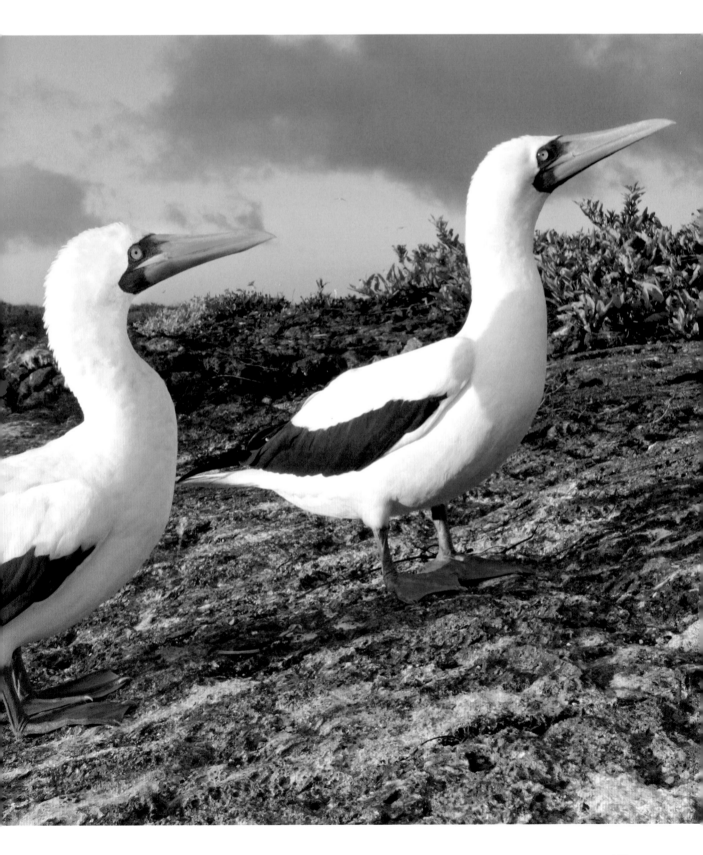

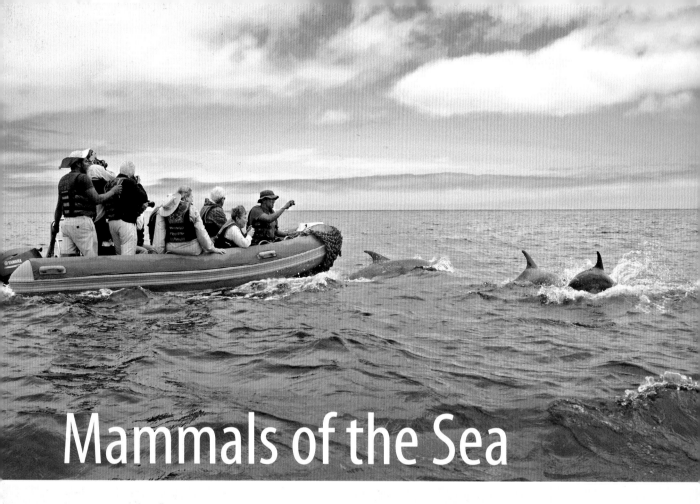

Mammals of the Sea

The average tourist is unlikely to see any native land mammals on a trip to the Galapagos, since there are only two small, shy rice rats and two species of bats.

Personally I have never seen a rice rat in more than a dozen trips to the islands, and I've seen a bat only once, when I was sitting in a restaurant after dark and watched one hunting moths around a streetlight in Puerto Ayora.

If you enjoy marine mammals, then the Galapagos has a lot more to offer. Roughly two dozen species of whales and dolphins swim in these waters, as well as a rare sea lion and an even rarer fur seal, both of which are found nowhere else. Whales and dolphins can be spotted most often around the distant islands of Wolf and Darwin, in the extreme northwest corner of the archipelago. Although I have seen a few killer whales and pods of common dolphins in the Galapagos, I have never seen any of the large whales that live there.

It's a completely different story with the sea lions and fur seals, which never fail to entertain on every visit. Until recently the Galapagos sea lion was thought to be a misplaced California sea lion, an animal that is commonly tamed and trained to do ridiculous tricks for aquarium audiences worldwide. Genetic studies have confirmed that the two animals separated roughly 2 million years ago; they are now recognized as two separate species that live separate lives.

The Galapagos fur seal is the other fin-footed marine mammal living in the islands. This

This juvenile Galapagos sea lion played with the prickly pear cactus pad for nearly 20 minutes.

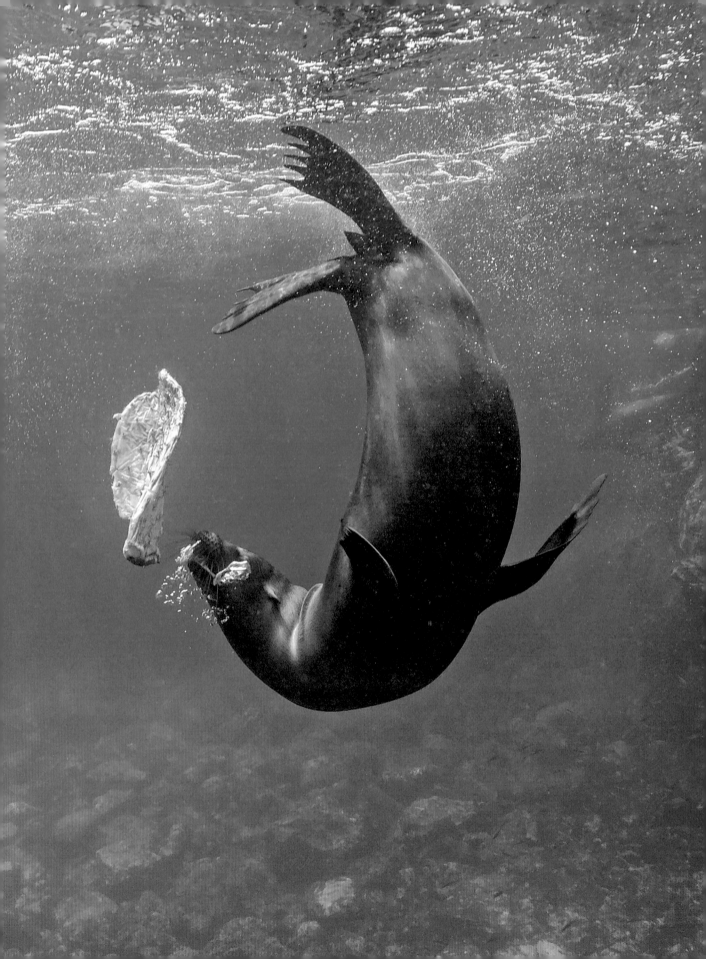

handsome little seal, the smallest in the world, was almost hunted to extinction in the 1800s. Whalers and sealers hunted them for their thick fur coats. Their numbers recovered slowly in the 1900s, but the population is still endangered, with fewer than 15,000 fur seals surviving.

When you compare the sea lion and the fur seal, you can see how their habits and physical attributes reduce competition between them. Sea lions are common, found on most sandy beaches throughout the islands. Fur seals, on the other hand, are scarce and occur mainly in the west of the archipelago, along rocky shorelines that are washed by the cold Cromwell Current. The sea lion is also a much larger animal than the fur seal: male sea lions weigh an average of 225 kilograms (496 lb) versus the

The Galapagos fur seal (**below**) prefers rocky, wave-battered coastlines, especially those in the west of the archipelago, whereas the Galapagos sea lion (**right**) is found on sandy beaches throughout the islands.

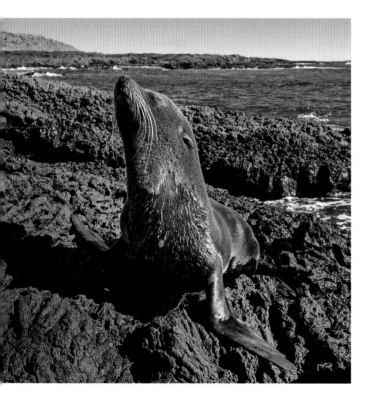

64 kilograms (141 lb) of the male fur seal. In both species the males are two to three times larger than the females. The large body size of the sea lion allows it to dive to depths of 500 meters (1,640 ft), whereas the smaller fur seal rarely dives deeper than 170 meters (558 ft).

Another difference between these two sea mammals is when they dive and what they hunt. Sea lions hunt mainly during the daytime and target schooling fishes like sardines, while fur seals hunt mainly at night, searching for deep-sea lanternfish. These large-eyed fish swim up toward the surface after dark and then retreat to deep water before daylight. The fur seal, for its size, has much bigger eyes than the sea lion — a necessary trait for seeing underwater at night.

For all their differences, the social structure is very similar in both species. Both gather in small colonies during the breeding season, when males fight each other for ownership of a short stretch of shoreline where they can then breed with any females that cross into their territory. As in all seals, both the fur seal and the sea lion give birth to a single pup. Raising a pup to independence in the Galapagos can be a challenge because ocean conditions vary so drastically. In some years food is abundant and in others extremely scarce. In the polar regions, where most sea lions and fur seals live, mothers normally stop nursing their pups after four months, but in the Galapagos they may provide milk to their pups for up to three years. A mother sea lion that gives birth every year might be nursing a one-year-old youngster as well as a newborn pup. Unless ocean conditions are ideal, the youngest pup usually gets much less milk and eventually dies.

An adult male fur seal will defend a small stretch of shoreline territory in which he has exclusive mating rights with any females that visit.

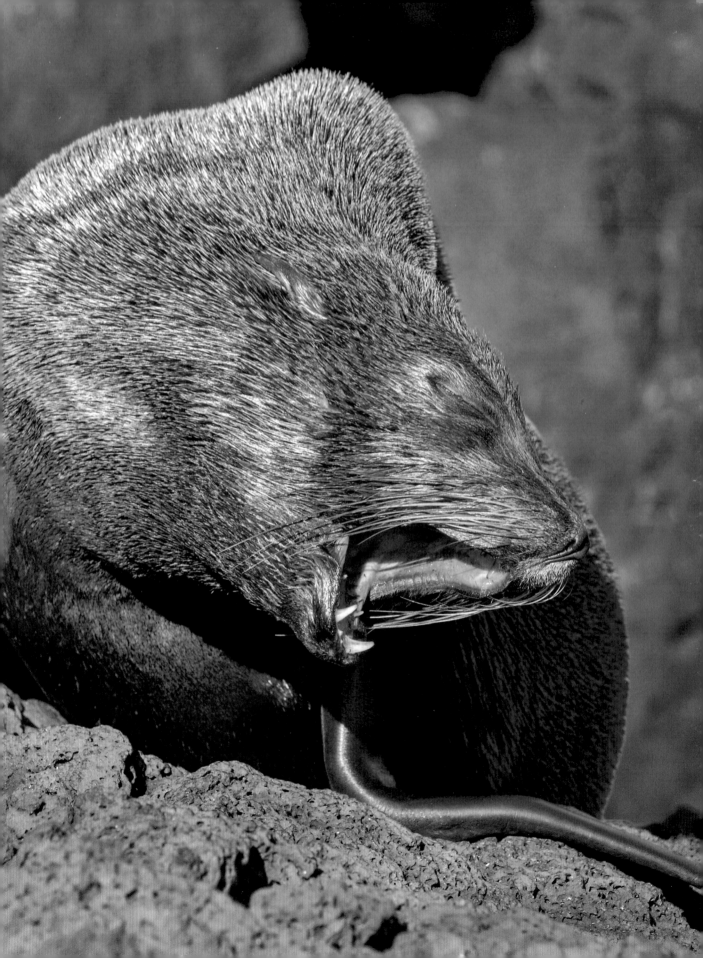

Recurrent El Niño warming cycles are one of the
major threats facing the Galapagos sea lion.

HIPPO

All of the world's remote island groups have felt the negative effects of human settlement, with losses of native vegetation, extermination of species and the

introduction of competitors and predators. The Galapagos Islands are no exception. A convenient way to summarize the conservation challenges facing the Galapagos is to use the abbreviation HIPPO:

H **Habitat loss**
I **Introduced species**
P **Population growth**
P **Pollution**
O **Overconsumption**

The impact that each of these has had on the Galapagos varies greatly.

Habitat loss in the Galapagos Islands has occurred mainly in one area. Currently almost 97 percent of the total area of the islands is protected as part of Galapagos National Park. The remaining

3 percent is concentrated in the moist highlands of the four islands where people have settled: Santa Cruz, San Cristobal, Floreana and Isabela. The moist highlands have the most predictable rainfall and the richest soil, making these areas attractive to farmers, who cut down the forests to grow crops and raise livestock. Recent satellite images suggest that more than half of the moist highlands on the four inhabited islands — almost 300 square kilometers (116 sq mi) — has been lost to agriculture.

The *I* in HIPPO stands for **introduced species**. Alien species have probably had the greatest impact on the islands. The invaders are of three main types: plants, domestic animals and insects. Among the foreign plants that have invaded the islands, some

were introduced on purpose by settlers and some came accidentally with shipments of livestock, contaminated crops or garden plants that ran wild. To date, more than 850 species of alien plants have been introduced to the islands. Two of these, the hill blackberry and the red quinine tree, have been unexpectedly damaging.

The hill blackberry, a native of the Himalayan Mountains in Asia, was introduced into San Cristobal in the 1970s. This weedy species grows quickly into dense thickets that smother all other vegetation. Unfortunately these berry bushes are difficult to eliminate, and fruit-eating birds spread their seeds, magnifying the problem. The red quinine tree was introduced into the highlands of Santa Cruz in 1946 as a source of malaria medication. Quinine trees, like the blackberry, form dense thickets that smother native plants. They also interfere with nesting Galapagos petrels by invading their burrows with a tangle of roots.

The introduction of domestic animals began with the pirates, who intentionally released goats on some of the islands as a source of fresh meat that they could harvest on later visits. With the settlers came more introductions, until the number of alien domestic species swelled to nearly a dozen, including cattle, donkeys, horses, sheep, pigs, dogs, cats, rats and guinea pigs. The damage began when these animals escaped into the wild. The predators among them preyed on lizards and native birds, the pigs uprooted tortoise nests, and the plant eaters voraciously stripped the vegetation, at times completely destroying the environment. However, on this issue there is room for hope. In recent

Feral dogs can cause the loss of many sea turtle nests.

The smooth-billed ani was introduced around 1970 and is implicated in the decline of vermilion flycatchers.

decades the authorities have spent millions of dollars to remove many of these alien animals. Gone are the wild horses, donkeys, cattle and pigs, and the goat, the most damaging plant-eater of all, has been eliminated everywhere except for small numbers on the islands inhabited by humans.

Hundreds of insects have been accidentally introduced into the islands through house plants. Six of these have been highly invasive: two species of fire ants, two paper wasps, the cottony cushion scale and the parasitic botfly. The first of the fire ants arrived in the early 1900s, and it is the most aggressive insect ever introduced into the Galapagos. These stinging ants prey heavily on native insects, land snails and nestling birds. They even disturb nesting land iguanas and giant tortoises.

The cottony cushion scale, first reported in the islands in the 1980s, is a sap-sucking bug that attacks at least 60 native plants. Carried by air currents, it has now spread to more than a dozen islands. The Australian ladybird beetle, which hunts and kills scale insects, was intentionally released on the islands in 2002 to control the scale outbreak. Scientists believe that the beetle will never completely eliminate the sap-sucking bug but may keep it at sufficiently low levels for it to be less destructive.

The introduced botfly behaves like some miniature monster from a horror film. The female fly lays her eggs in the nostrils of baby finches, mockingbirds and other small songbirds. Once the eggs hatch, the hungry grubs may burrow into the bird's brain, killing it outright, or fall off into the nest and then repeatedly feed on its blood. In infected nests, all the hatchlings may die.

Represented by the first *P* in HIPPO is **population growth**. More humans in any environment always means more of all the other HIPPO effects. In 1942, when the US government built its lengthy runway on Baltra Island during the Second World War, the population of the islands was a scanty 800, most of them fishermen and farmers. Today the permanent population is over 35,000. Add to that more than 200,000 annual visitors and you have an archipelago straining at the seams. Having so many humans on these small islands means there is greater pressure on the environment. Fresh water, food and fuel need to be imported, and every load of imported food and every passenger-filled aircraft and luxury yacht carries the potential to introduce more alien species, with unknown consequences.

The second *P* in HIPPO stands for **pollution**. In January 2001 the fuel tanker *Jessica* went aground off San Cristobal Island, spilling 700,000 liters (185,000 gal) of toxic diesel oil and 284,000 liters (75,000 gal) of fuel oil into the pristine waters of the archipelago. The shorelines of Floreana and Isabela were the worst affected, with lesser amounts soiling Santa Fe, Santa Cruz and San Cristobal. Fortunately the impact on shore communities of seaweeds, crabs and fishes was slight, although 60 percent of the marine iguanas on Santa Fe Island died later that year, presumably from the stress of the event. Seventy-nine sea lions were oiled during the spill but none died as a result.

A scientific report on the biological impacts of the

The yellow warbler is one of the many avian victims of the introduced parasitic botfly, whose larvae often kill those they infect.

spill concluded: "Compared to other spills of this size, it seems as though the Galapagos Islands were lucky, as most of the oil apparently threaded through the archipelago to the southwest without coming ashore." But as the human population of the islands has increased, tanker traffic has grown to meet the demands. Every week there are now dozens more fuel tankers and cargo ships supplying the islands. Another oil spill is predictable. Will the archipelago be as lucky the next time?

The last of the HIPPO threats is **over-**

Sport fishing is prohibited in the Galapagos Marine Reserve, although limited commercial fishing by residents is allowed.

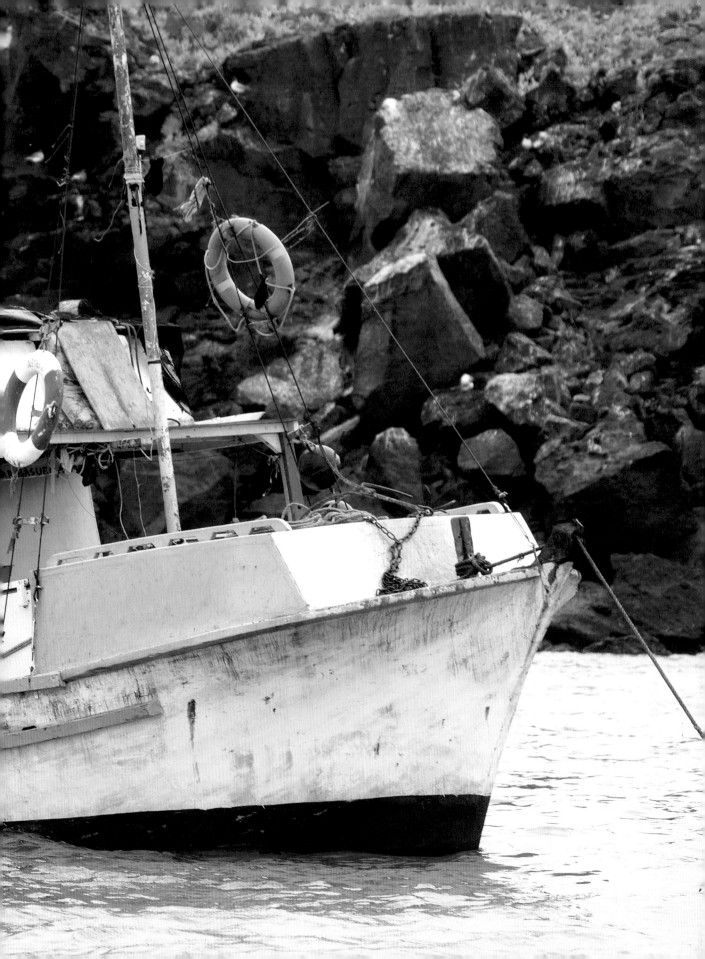

The skeleton of a flightless cormorant resulted from an El Niño event in which many seabirds died.

consumption. Tourism benefits the locals, and more and more Ecuadorian citizens have moved to the islands to take advantage of the better wages and living conditions. These new arrivals put pressure on national park authorities to loosen fishing regulations. In the 1980s fishermen caught so many lobsters that the population collapsed, and it has never recovered. In the late 1990s, sea cucumbers caught for the Asian luxury food market became the new target. In the following five years, divers harvested more than 18 million sea cucumbers; in 2006 the fishery had to be closed in an effort to save the species from extermination. The divers protested so much that they were allowed to take a limited harvest after that, but sea cucumbers remain scarce.

The final threat to the Galapagos Islands is **global warming**, a threat shared by the entire planet. Scientists predict that our warming atmosphere will result in more frequent and more powerful El Niño events. In the Galapagos, four species are most at risk. Galapagos penguins and flightless cormorants have always been especially vulnerable to El Niño events; predicted climate warming may cause extreme population declines and possibly extinction.

With global warming, glaciers are melting and sea levels are rising. Nesting beaches for green sea turtles may disappear and increases in sand temperature may alter the sex of hatchlings, leading to more females and fewer males. Marine iguanas are also under threat from El Niño events. In the past, severe El Niños have killed as many as 90 percent of the iguanas. They are greatly impacted because their favorite food, red and brown algae, dies when the ocean warms. Other types of algae survive but are not as easily digested by the iguanas, so they slowly starve.

Even with all the challenges they face, the Galapagos Islands have managed to retain 95 percent of the diversity they had before the first humans arrived. There are many reasons to be thankful. As scientists continue to study and understand this isolated ecosystem, they are better able to plan for the future so that this unique and marvelous archipelago continues to be worthy of the title "the most famous islands in the world."

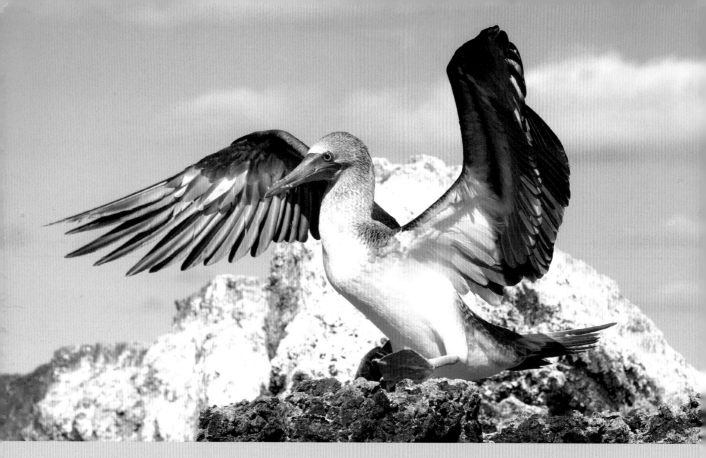

The blue-footed booby **(above)**, the endemic marine iguana **(below)**, the Galapagos cotton **(opposite top)** and the candelabra cactus **(opposite bottom)** are just four reasons why the Galapagos Islands are one of the most popular nature destinations on the planet.

Further Reading

DeRoy, Tui, ed. *Galapagos: Preserving Darwin's Legacy.* 2nd ed. New York: Bloomsbury, 2016.

Galapagos Conservancy. *Galapagos News* [quarterly online newsletter]. http://www.galapagos.org.

Jackson, Michael. *Galapagos: A Natural History.* 2nd ed. Calgary, AB: University of Calgary Press, 1993.

Kricher, John. *Galapagos.* Smithsonian Natural History Series. Washington, DC: Smithsonian Institution Press, 2002.

Larson, Edward. *Evolution's Workshop: God and Science in the Galapagos Islands.* New York: Basic Books, 2001.

Nicholls, Henry. *The Galapagos: A Natural History.* New York: Basic Books, 2014.

Weiner, Jonathan. *The Beak of the Finch: A Story of Evolution in Our Time.* New York: Alfred Knopf, 1994.

Photo Credits

Index

Note: page numbers in bold refer to pictures.

Meet the Author

In 1979, at the age of 31, Dr. Wayne Lynch left a career in emergency medicine to work full-time as a science writer and photographer. Today he is one of Canada's best-known and most widely published professional wildlife photographers. His photo credits include hundreds of magazine covers, thousands of calendar shots and tens of thousands of images published in more than 70 countries. He is also the author and photographer of over a dozen highly acclaimed natural history books for adults, including *Penguins of the World*; *Bears: Monarchs of the Northern Wilderness*; *A Is for Arctic: Natural Wonders of a Polar World*; *Married to the Wind: A Study of the Prairie Grasslands*; *Planet Arctic: Life at the Top of the World*; *The Great Northern Kingdom: Life in the Boreal Forest*; *Owls of the United States and Canada: A Complete Guide to Their Biology and Behavior*; and *Penguins: The World's Coolest Birds*. His books have been described as "a magical combination of words and images."

Dr. Lynch has observed and photographed wildlife in more than 60 countries and is a Fellow of the internationally recognized Explorers Club, headquartered in New York City. A Fellow is someone who has actively participated in exploration or has substantially enlarged the scope of human knowledge through scientific achievements and published reports, books and articles. In 1997 Dr. Lynch was elected a Fellow of the Arctic Institute of North America, in recognition of his contributions to knowledge about polar and subpolar regions.